IMAGES
of America

VICTORIAN CHILDREN
OF
NATCHEZ

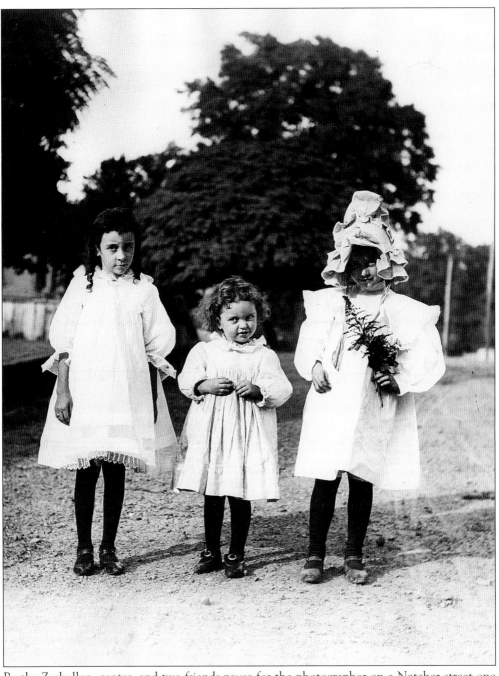

Bertha Zurhellen, center, and two friends pause for the photographer on a Natchez street one sunny day 100 years ago.

IMAGES
of America

VICTORIAN CHILDREN
OF
NATCHEZ

Joan W. Gandy and Thomas H. Gandy

ARCADIA

Published by Arcadia Publishing
Charleston SC, Chicago IL, Portsmouth NH, San Francisco CA

Printed in Great Britain

Library of Congress Catalog Card Number: 2005929346

For all general information contact Arcadia Publishing at:
Telephone 843-853-2070
Fax 843-853-0044
E-mail sales@arcadiapublishing.com
For customer service and orders:
Toll-Free 1-888-313-2665

Visit us on the internet at http://www.arcadiapublishing.com

With affection for our grandchildren:
Mary Margaret, Anna Magee, Robert, Thomas, Eliza, Owen, and William

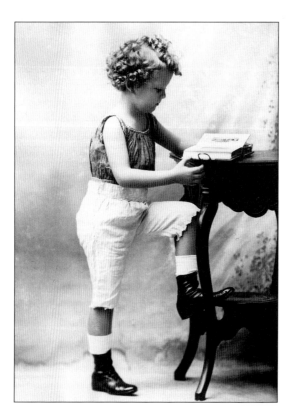

Lemuel P. Conner III reads a favorite book in about 1898.

4

CONTENTS

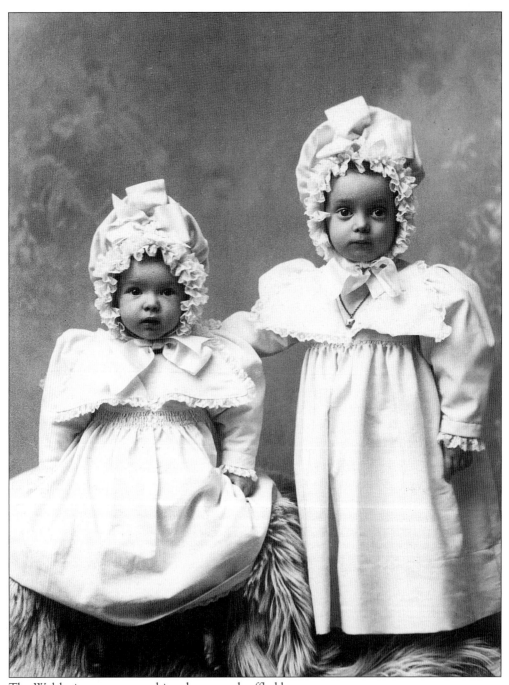

The Welsh sisters wear matching dresses and ruffled bonnets.

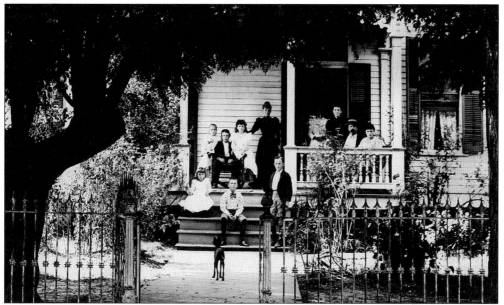

Judge John S. Boatner and his family pose in the 1880s on the porch of their fine Victorian cottage in Vidalia, Louisiana, across the Mississippi River from Natchez.

INTRODUCTION

Natchez, Mississippi, is a small Southern town where a photographic record spanning nearly 100 years has survived to tell the story of the town's people with stunning detail. Known today for its collection of pre–Civil War mansions built from fortunes made during the great cotton boom of the mid-19th century, Natchez in reality always has claimed a people of diverse ethnic and socio-economic backgrounds. *Victorian Children of Natchez* provides a glimpse into a special time in Natchez and all over America, when the adult world began to look upon childhood with unprecedented nostalgia.

Families gathered on their porches or in their parlors then, where Father read from Dickens or Hawthorne, and Mother played the piano for all to sing along. School lessons taught moral values. Roller skating, baseball, tip-cat, and picnics filled carefree summer days.

Change was rampant across the continent in the decades following the Civil War. An era in American history had passed. A new industrialized, exuberant one dawned. The idealizing of childhood came as the continent was linked by railroads and the great frontier at last was subdued.

The exquisite photographs in *Victorian Children of Natchez*, along with the explanatory text, reveal decade by decade the subtle changes in the life of a child during a 50-year period, from 1865 to 1915. The children photographed just after the Civil War appear as miniature adults, their young faces reflecting a sober maturity. The children of the 1880s and 1890s, however, emerge merrier in demeanor.

The Victorian era did not end abruptly with the death of Queen Victoria of England in 1901; nor did the turn of the century herald any remarkable changes from what had been known in the 1890s. Yet, for children, the gradual changes that had evolved since the end of the Civil War peaked in the early 1900s. The last of the Victorian children grew up to face a world war and technological advances that precluded innocence and naiveté.

This work is a revised edition of an out-of-print book, *Natchez Victorian Children*, published by the authors in 1981. Other books based on the extraordinary collection of Dr. Thomas H. Gandy and Joan W. Gandy are *Norman's Natchez: An Early Photographer and His Town* (published by University Press of Mississippi in 1978) and *The Mississippi Steamboat Era* (published by Dover Books in 1987).

The Gandy photographic collection begins with the work of photographer Henry Gurney, who came to Natchez as a daguerreotypist in the early 1850s and who in 1870 hired 20-year-old Henry C. Norman as his assistant. Norman succeeded Gurney and worked in Natchez until his death in 1913. Earl Norman, Henry's son, took over the photography studio and operated it until his death in 1951.

In 1960 Dr. Gandy, then a practicing medical doctor in Natchez, purchased the photographic collection from Earl's widow. The tens of thousands of negatives, glass and celluloid, range in size from about 3-by-5 inches to 11-by-14 inches. In addition to the beautiful collection of portraits from which images for *Victorian Children of Natchez* were selected, the negatives include street scenes, Mississippi River steamboats and river scenes, family groups, celebrations, rural life, and more.

One
EARLY YEARS

Miniature adults peered soberly into the camera, their stiff poses and even the photographer's fanciful seascape backdrop recalling portraits that might have been painted in the earlier part of the century by itinerant artists. The photographer's elements differed from the portrait painter's, of course. The polished wooden camera rested upon a footed stand fitted with wheels for mobility but seldom moved from the center of the studio, where it focused upon the primary prop, a fringed chair upholstered in plush. The portrait was made quickly. Hours and days of posing were a thing of the past. In a matter of minutes, the camera had worked its magic, recording an instant in clear detail: frayed dress, freckled face, uncombed hair, tilted head, worried brow, and even occasionally Mother's knees as she sat reassuringly near. After all, the photograph was still quite new and not always understood.

George Schwartz gazes seriously toward the photographer in the early 1870s.

In a classic pose, John Edward Schwartz and his sister, Katie B. Schwartz, children of Catherine and John Conrad Schwartz, sit and stand rigidly still for this 1865 photograph made by Natchez artist Henry Gurney. Gurney arrived in Natchez in the early 1850s to join his brother, daguerreotypist Marsh Gurney. Marsh died of yellow fever in 1858 and in his will bequeathed his rifle and his "large camera" to his brother Henry.

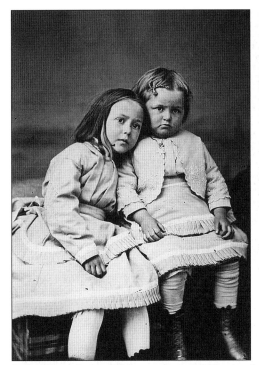
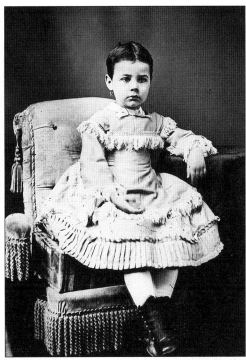

Left: The Mock children, about 1865, sit close together. *Right:* Juliet Rawle, 1872, was a granddaughter of Frederick Stanton, who built the famous Natchez mansion Stanton Hall.

Left: An unidentified girl poses with her doll in the 1870s. *Right:* Miss Ogden frowns unhappily in an 1870s portrait.

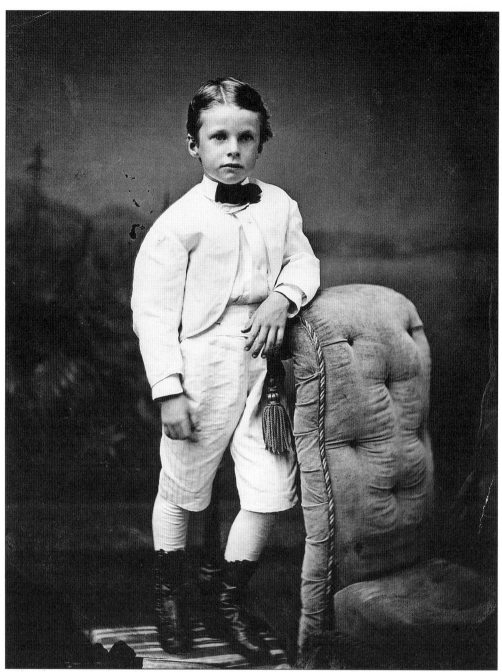

Little Mr. Cochran wears a summer suit for this 1860s photograph. Photography still was a new-fangled thing in the 1860s. After all, it was only in 1839 that Frenchman Louis-Jacques-Mande Daguerre had announced his method of making a permanent image on silver-coated copper. The French government shared the technique with the world. Soon known as the "daguerreotype," this leap in the art of photography set the stage for many new discoveries to follow in a period of only a few decades. Little Mr. Cochran's image was recorded on a wet-plate negative, a method dating to the early 1850s.

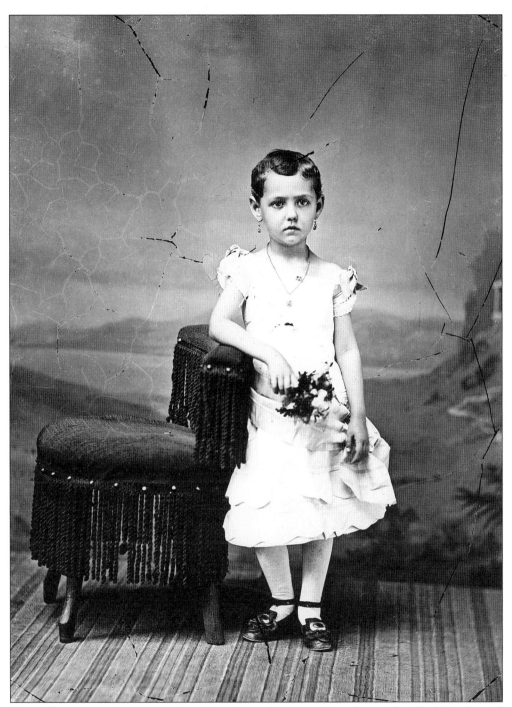

A small bouquet and pretty jewelry soften the somber expression of an unidentified Natchez girl in the 1870s. In Natchez, the 1870s found many people continuing to suffer the aftermath of war. Although Natchez was not the site of a battle and little destruction occurred during the Civil War, many of the town's people—black and white and across all socio-economic groups—were left poor and with few resources.

Young Adelaide Petagna visits the Natchez photographer in 1876, three years after her immigration to America with her family from Naples, Italy. Natchez has been a city of many cultures from its earliest history. However, 19th-century immigration into the city particularly enriched the population with many new ethnic groups, including Italian families such as Adelaide's.

Young Mr. Koerber, 1870s, wears an adult-style three-piece suit and shiny boots.

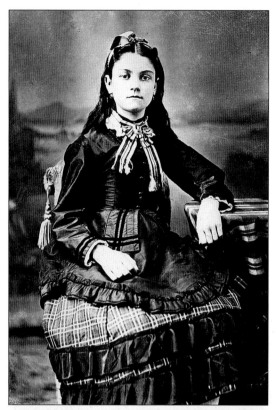

Three young ladies show off varying styles worn in the 1860s, each with a bow at the neck of the dress. Different jewelry and hairstyles distinguish one girl from the other, but similarities—all have their hair parted in the center, for instance—are evident. At left is Jennie Stietenroth, who became a teacher at the Natchez Institute. She is pictured 30 years later with some of her students on pp. 80–81. Below, at right, is Miss Ventress. The third young lady, below at left, is unidentified.

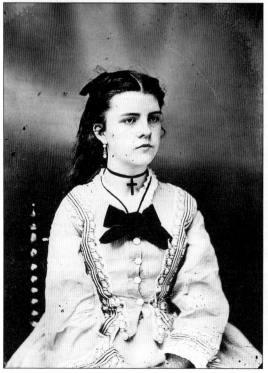

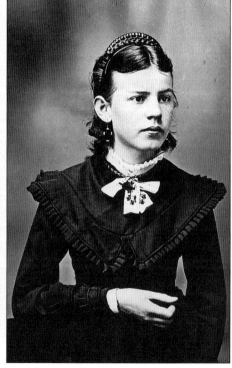

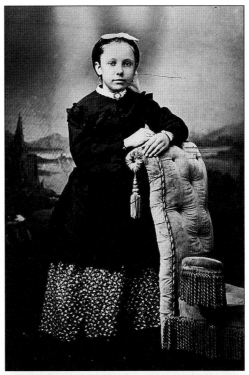

All three of these children are unidentified. Sadly, many portraits in the Gandy Collection of Natchez photographs are unidentified or have only part of the name with which to search for more information. On the other hand, thousands of portraits were identified by markings on original envelopes in which the negatives were kept or by names written directly on the glass or cellulose negatives. Many hundreds of others have been identified during the past 35 years after having been seen by family members or old-timers in the community.

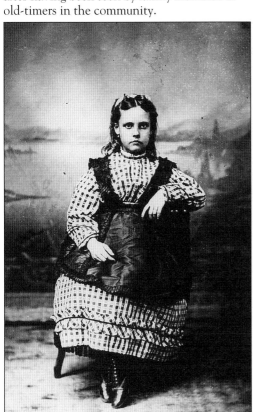

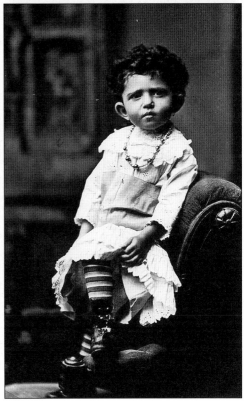

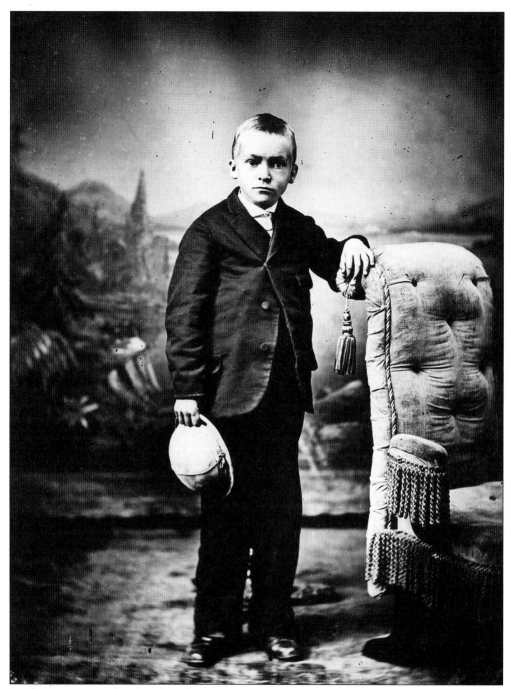

In the years immediately after the Civil War, when this photograph was made, children continued to wear outfits very similar in appearance to adult clothing. Here, the stylish hat appears an important element of the unidentified boy's costume. In fact, the variety of popular hat styles of the period is quite surprising.

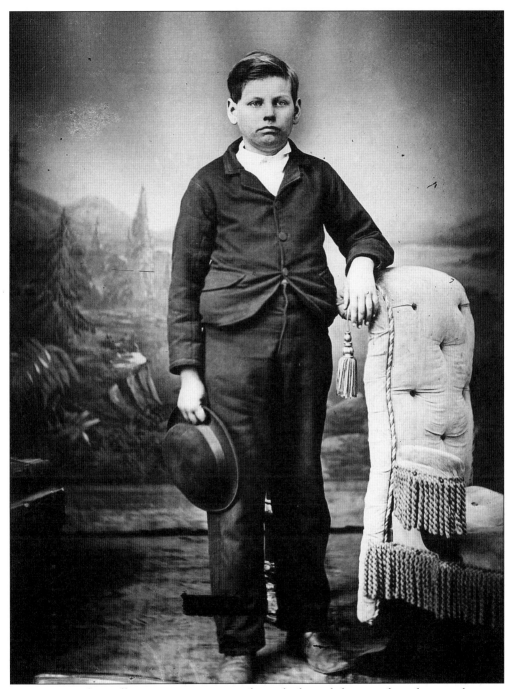

A patron's perfect stillness was important in the early days of photography, when emulsion on the glass responded slowly to light through the camera's lens. Behind young Mr. Postlethwaite, shown here posing in the 1860s, and behind the young man on the opposite page, a mechanical device to aid in stillness is partially visible. The metal stand rose to support forceps-like clamps which held the patron's head in place.

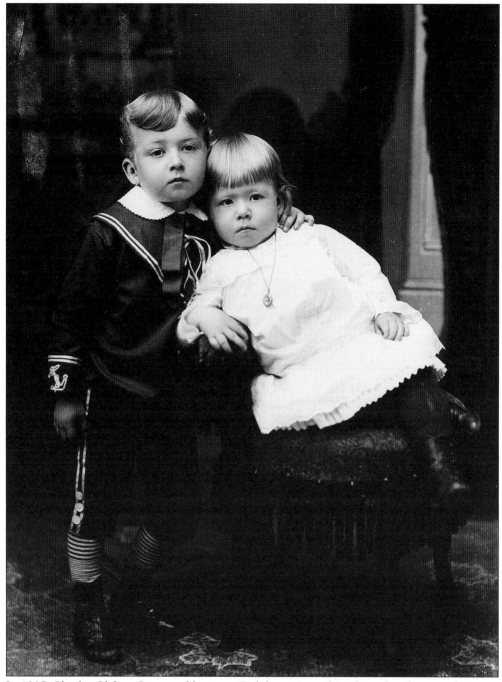

In 1885, Charles Clifton Goetz and his sister Delphine gaze solemnly at the photographer.

Two
THE 1880S

During the 1880s, a new and refreshing view of children emerged from the photographic studio. Perhaps because the photographer's techniques had improved, children began to appear more relaxed before the camera, and even occasionally smiled. As a newspaper article in 1882 pointed out, the photographer often went to extremes then to get a good picture, from supplying "pacificatory blandishments" and "keecher-keecher-keecher" to jingling a bell, clucking like a hen, or compromising his soul by telling the child "that if he will hold still, a white mouse will run out of the camera." In the 1880s, Henry C. Norman's gifts as a portraitist began to blossom. New photographic know-how and Norman's natural talents combined to create in his work some of the most beautiful portraits made in the period, including those of children.

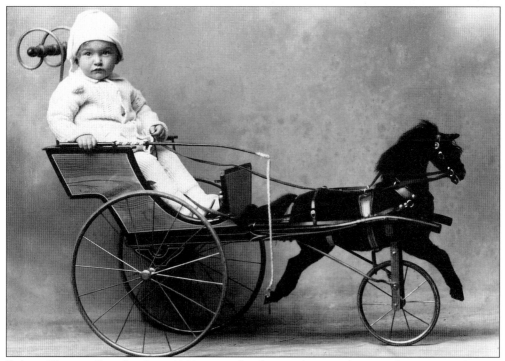

Robert Clement French, about 1880, sits in his fine toy buggy. The son of Dr. James Clement French, who practiced medicine in Natchez from the 1870s to 1912, young Robert Clement also grew up to become a medical doctor. However, he died in 1914, only two years after his father.

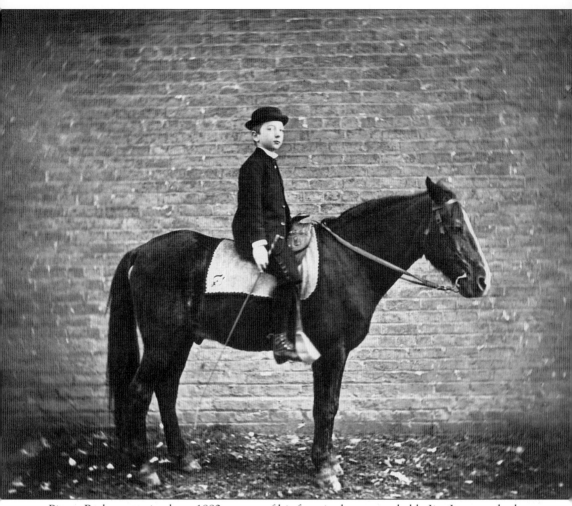

Pierce Butler poses in about 1882 on one of his favorite horses, probably Jim Jumper, the horse born in 1880, the same year his brother Jim was born. Pierce later wrote of Jim Jumper in his autobiographical book *The Unhurried Years*, "He was a finely built light bay of great speed, and perfectly sure footed withal as gentle as any lady's horse, probably because he had been brought up in the front yard and early learned to be petted and even to walk up the front steps, one time into the open parlor doors."

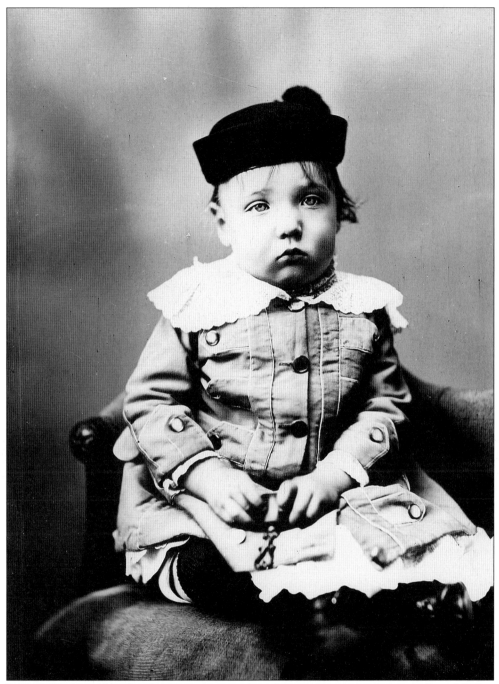

James P. Butler and his brother Pierce, pictured on the opposite page, grew up at Laurel Hill, a plantation south of Natchez near the Mississippi River. Jim later served as president of Canal Bank in New Orleans; Pierce in later years was dean of the prestigious New Orleans women's college Sophie Newcomb at Tulane University.

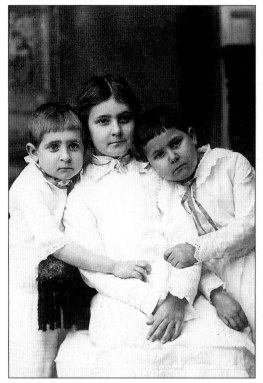

Identified only as "the orphans," the three children pictured at left may have been residents of the Natchez Protestant Home, one of the oldest institutions of its kind in the country and now operated as the Natchez Children's Home. Below are sisters Adlyne Van Court (left), the younger of the two, and Catherine Van Court, both photographed in about 1880 with favorite dolls. Daughters of Dr. Elias Van Court, a physician, the girls lived in an elegant townhouse on Washington Street in Natchez and on a rural estate named Courtland.

Brothers Robert James Eisele and Francis Vincent Eisele are smartly attired for this photograph, made in about 1888.

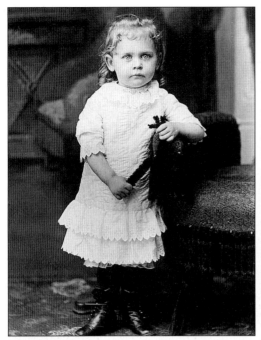 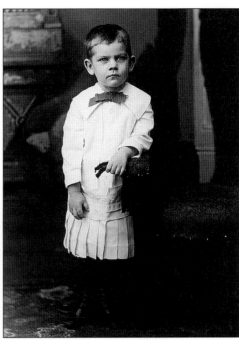

Miss Hays (left) and her brother posed in the 1880s. The Hays family lived in Waterproof, Louisiana.

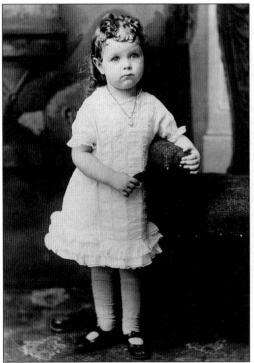 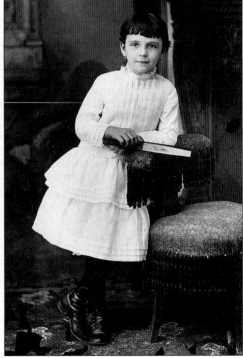

Left: Mary Irvine Donaldson's father owned Donaldson's Book Store. *Right:* Mary Balfour lived with her family at palatial Homewood, built by her father only a few years before the Civil War began.

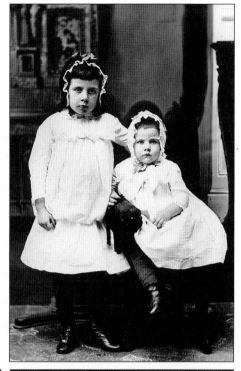

Ethel and Maretta Cannon, at right, lived in the small settlement of Cannonsburg a few miles from Natchez. Their family founded the town in the early 19th century. Below at left is a daughter of Mrs. James Ogden, showing off a grand bonnet. The unidentified child below at right holds a fancy feathered hat, sadly not worn for the photograph. All the girls posed in the early 1880s.

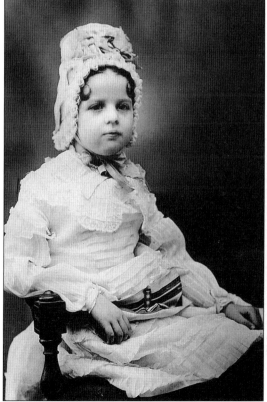

 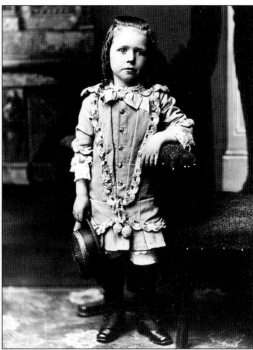

Left: Charles Williams wears a skirt, certainly stylish for young fellows; but his is a decidedly boyish haircut. *Right:* Young Mr. Hawley wears a boldly trimmed suit and long curls.

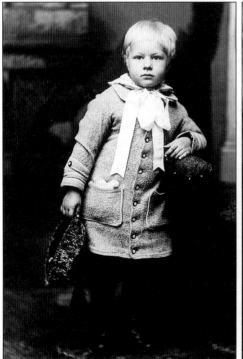 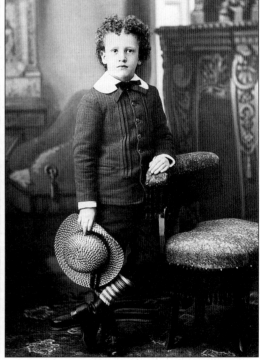

Left: Audley Britton Stone is dressed for a winter day in about 1884. *Right:* Matthew Addison Flood wears a typical schoolboy suit.

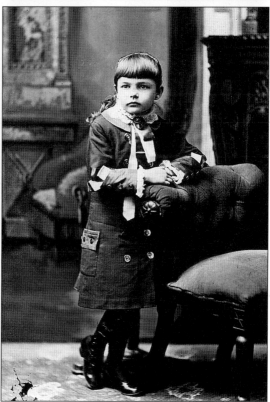

At right, Laura Louise DeLap wears a version of the old-fashioned poke bonnet. Laura Louise's father, E. George DeLap, operated an insurance business in Natchez. Below, the boy in a handsome velvet suit and the girl in a double-breasted coat-style dress are unidentified.

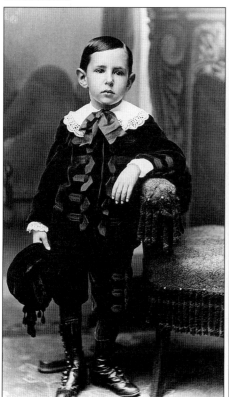

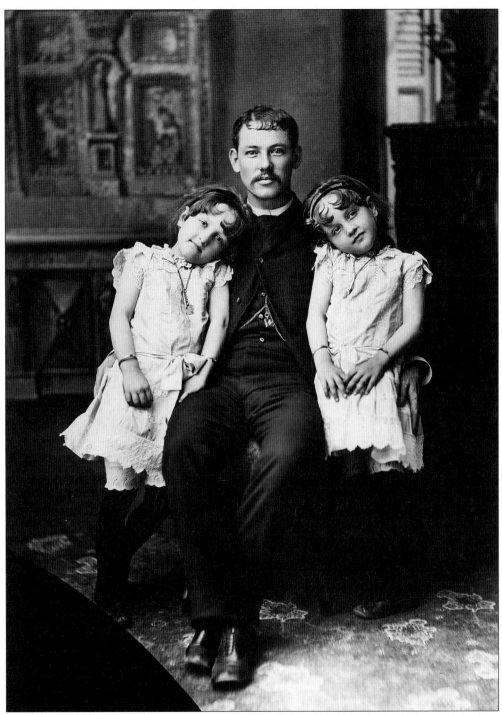

Mr. Bing is flanked by his twin daughters, who match from head to toe, from the curls on their foreheads to the striped hose extending from beneath the lace-edged pantalets.

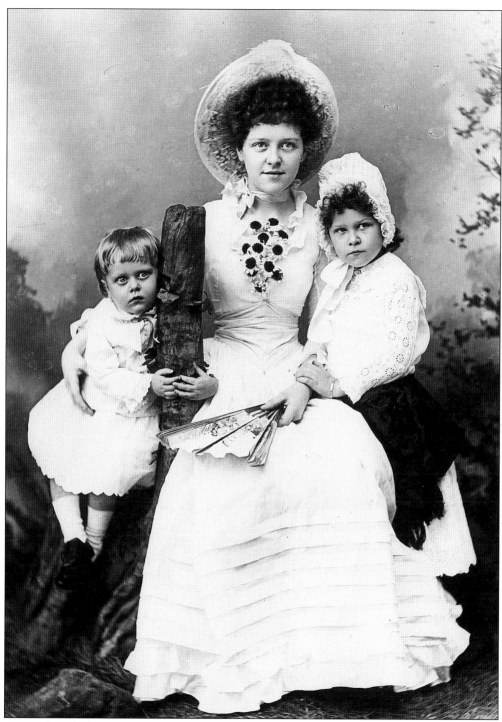

An unidentified mother sits between two children, all smartly dressed for their photograph to be made in the late 1880s at Norman's Studio on Main Street.

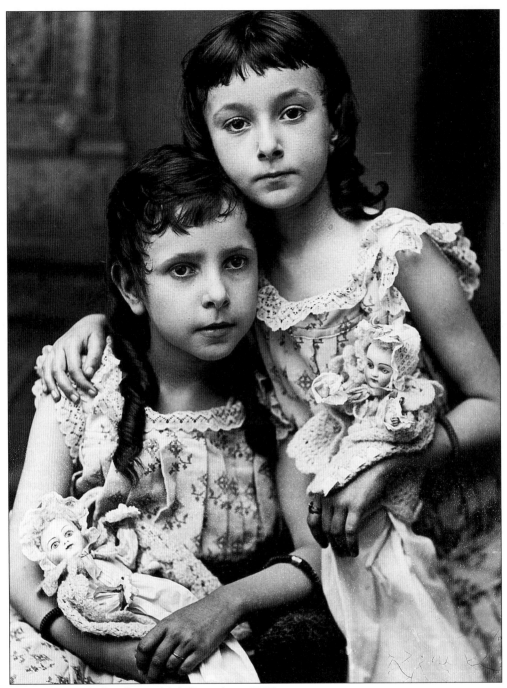

Sisters pose with their beautiful dolls in about 1885.

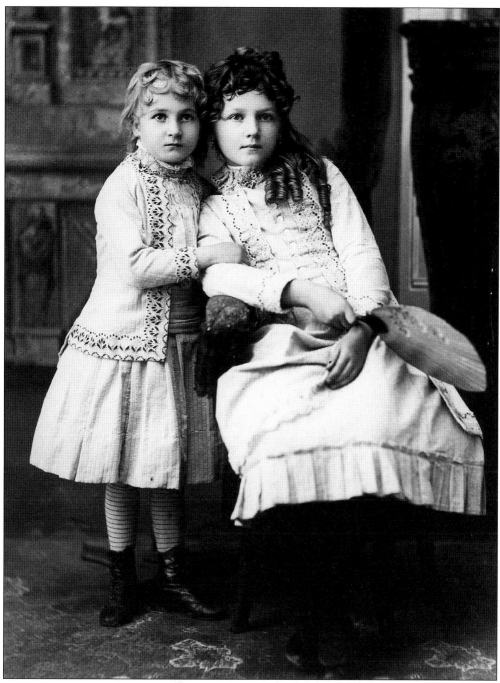

Unidentified girls display interesting dress styles of the 1880s.

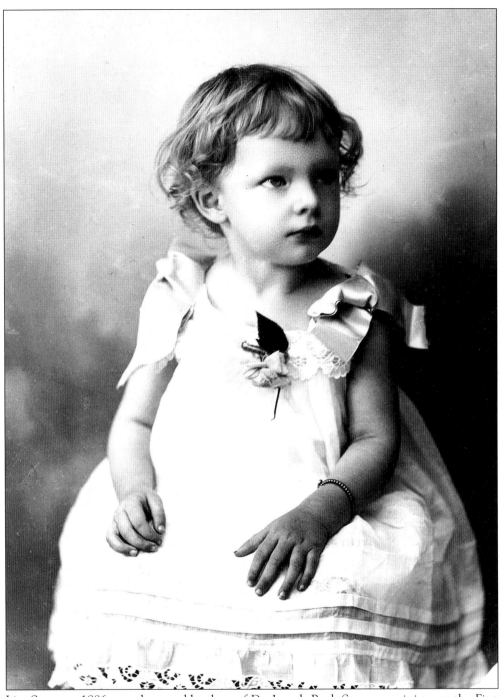

Lisa Stratton, 1886, was the granddaughter of Dr. Joseph Buck Stratton, minister at the First Presbyterian Church in Natchez for half of the 19th century.

Boys from three prominent families pose for 1880s portraits. At right are John Ashton Shields and his younger brother, Thomas Clifton Shields. John became an attorney; Thomas Clifton died of yellow fever at age 20 in 1898. At bottom left is Moses Ullman, one of the children of Samuel Ullman. At bottom right is John Rawle Jr., grandson of the prosperous Frederick Stanton, who built Stanton Hall in the 1850s.

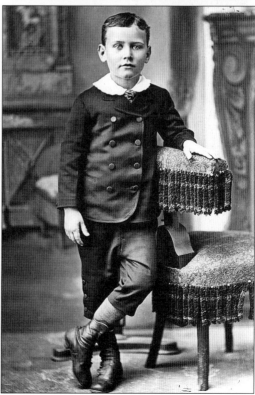

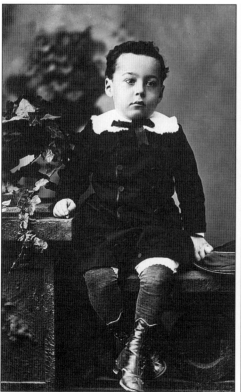

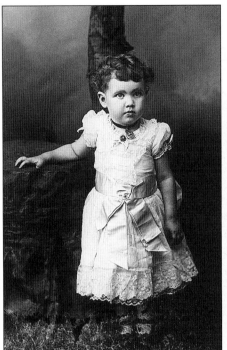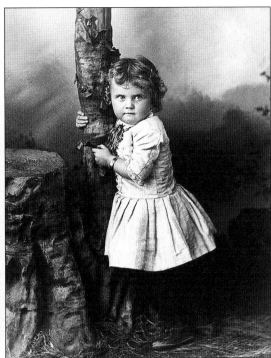

Left: The daughter of Dr. Benjamin Chase, Anna Chase, about 1888, wears a frilly organdy dress with satin sash. *Right:* Margaret Pitchford, about 1886, almost manages a smile for the photographer.

Frank Hootsell and his dog, 1888, appear equally comfortable before the camera.

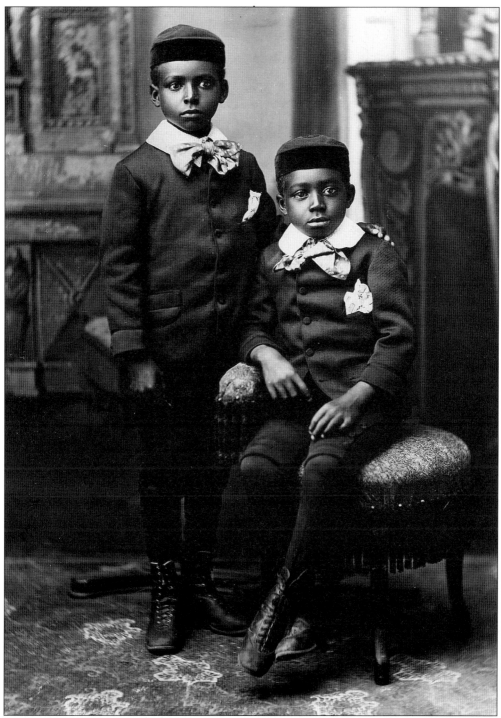

The handsome Ballard brothers, sons of Roy Ballard, pose in about 1885. This portrait was a special hit in London, England, when about 225 photographs from the Gandy Collection were shown in an exhibit at the Barbican Centre. Many newspapers and magazines chose this photograph to appear with articles about the exhibition.

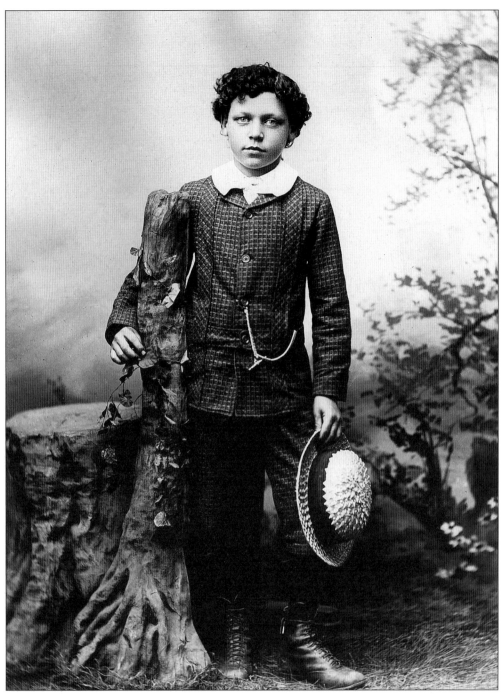

Benton Alexander St. John, 1887, wears a stylish checked suit. Photographer Henry C. Norman chose the wet collodion plate to produce most images made in the 1880s, including this one. The wet-plate process was slower than the new gelatin dry plate coming onto the market during this decade, but Norman's wet-plate negatives continue to yield exquisite images more than 100 years later and have shown less deterioration than the faster, more convenient dry plate method he used a few years later.

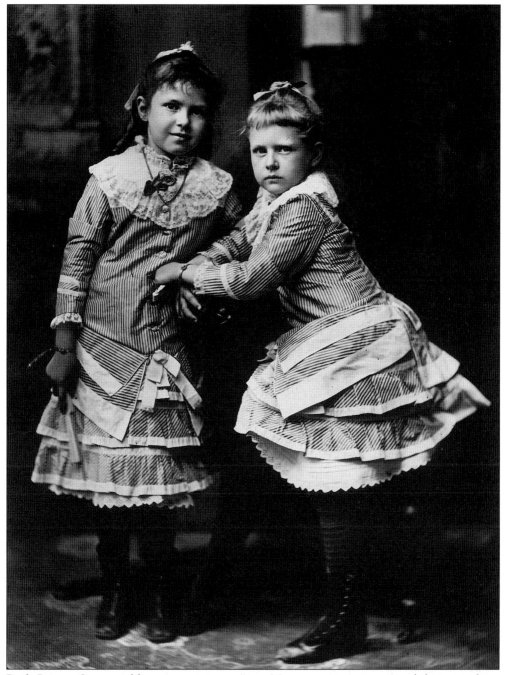

Ruth Britton Stone and her younger sister Anna Mary wear summery striped dresses perhaps made on one of the popular Singer sewing machines that all well-equipped households had in the 1880s.

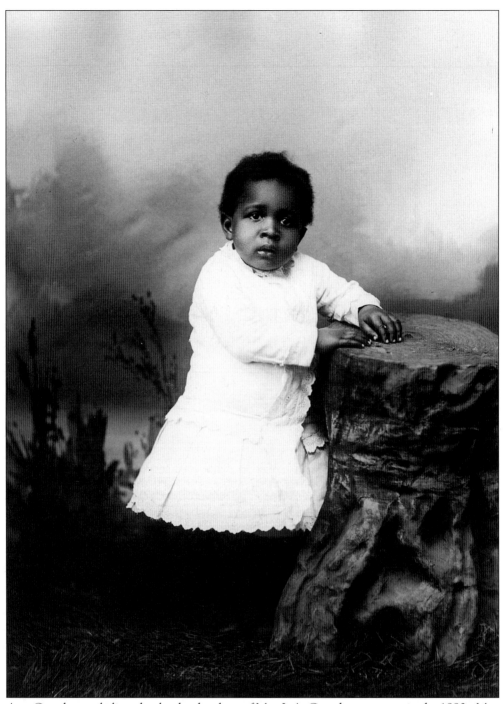

Ann Granderson, believed to be the daughter of Mrs. L.A. Granderson, poses in the 1880s. Mrs. Granderson was a teacher at the Union School, now gone but then located at the corner of Union and Monroe Streets near downtown Natchez.

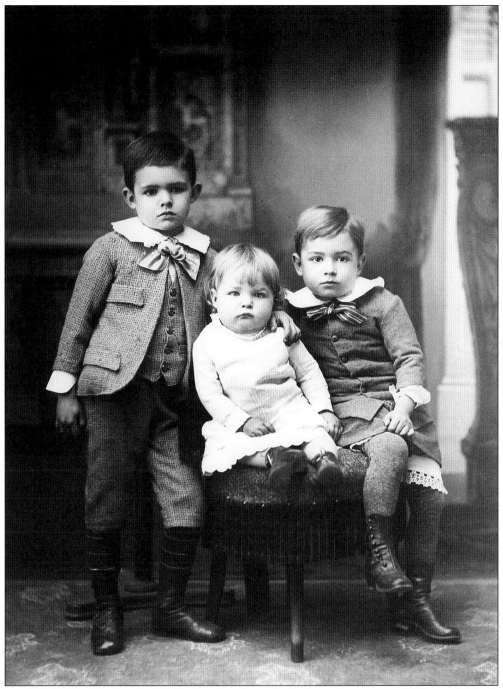

Unidentified brothers in the early 1880s handsomely display a progression of fashions for little boys: from the dress for the youngest to the short pants worn over lacy pantalets to, at last, the knee pants.

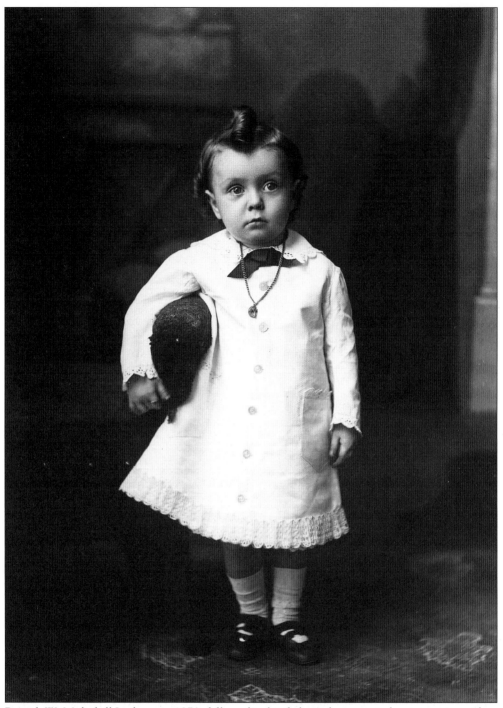

Patrick W. Mulvihill Jr., born in 1879, followed in his father's footsteps to become a tinsmith, a successful businessman, and a civic leader.

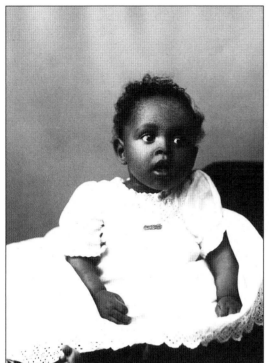 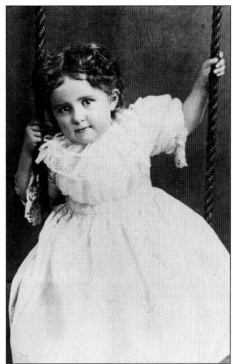

Left: Something appears to have caught the eye of Mrs. Coleman's baby. *Right:* An unidentified child poses on a swing.

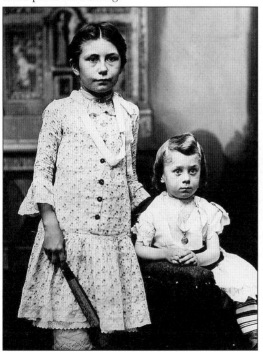 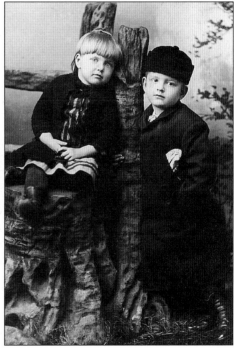

Left: The daughters of Natchez Mayor Henry Benbrook pose in 1885. *Right:* Henry Kingsley Hutton and Lillian Archer Hutton wear winter garb.

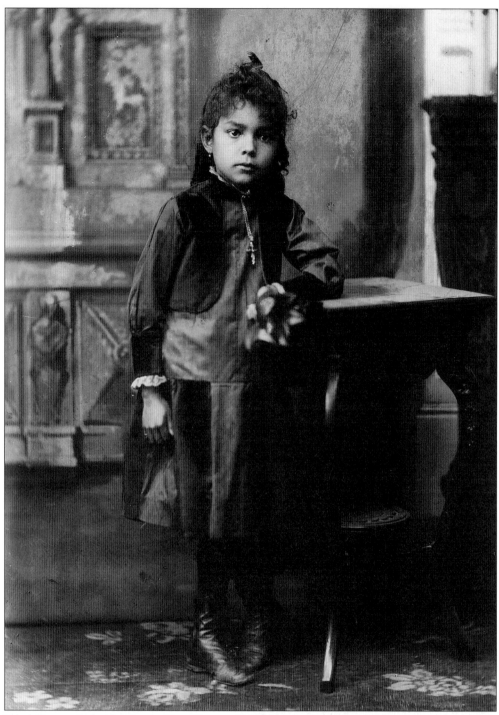

Ethyl Garrett is the daughter of Lou Garrett. Ethyl is one of numerous African Americans who posed for Norman in the decades following the Civil War. Natchez was home to the largest population of free blacks in Mississippi in the pre-Civil War years. The area is rich in black history and today has a population nearly equally divided between blacks and whites.

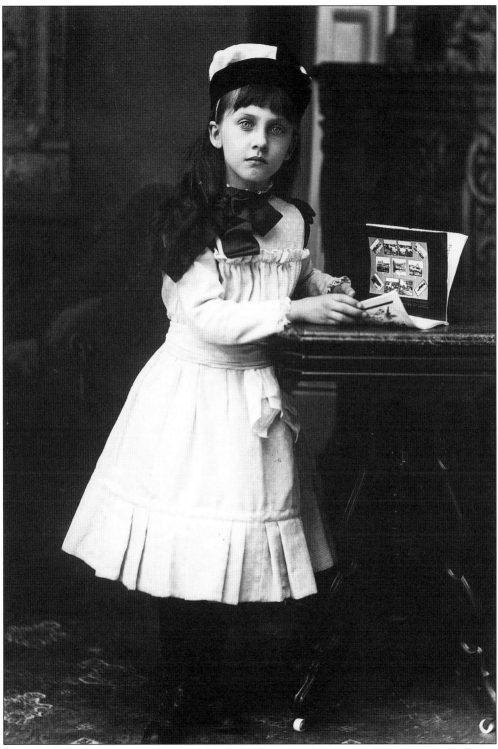

An unidentified girl, about 1885, looks through a photo album, perhaps one made during vacations at a resort visited during the summer months.

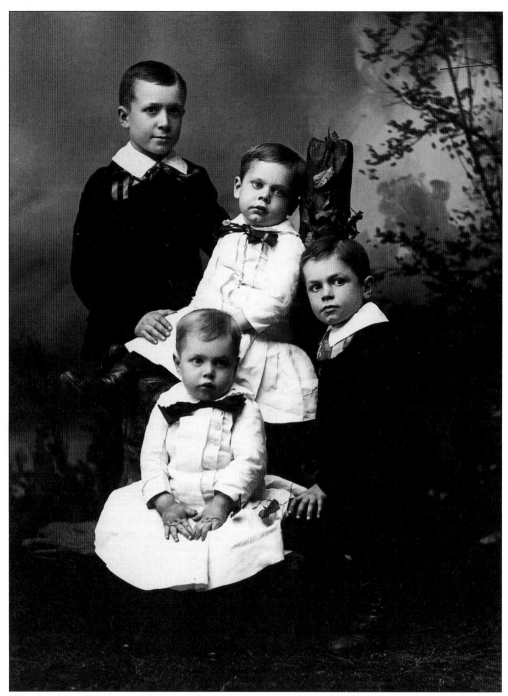

The Singleton brothers make a handsome foursome in their 1888 portrait.

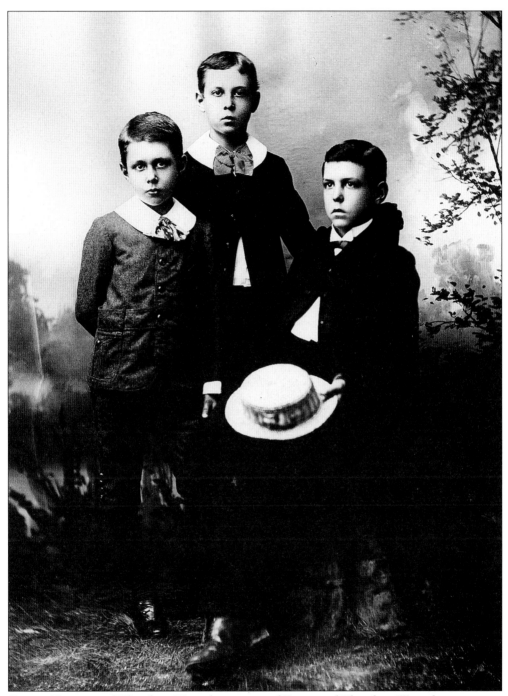

George, Francis, and Theodore Wensel were sons of Emma and Theodore Wensel, a partner in the firm Rumble and Wensel. Francis took part in the 1898 Spanish-American War, returning home with the dreaded tuberculosis. George left medical school to take his brother west for a cure. However, George, too, became ill with the disease. Theodore and his sister Sallie are pictured on p. 108 in costumes worn in The Kermiss.

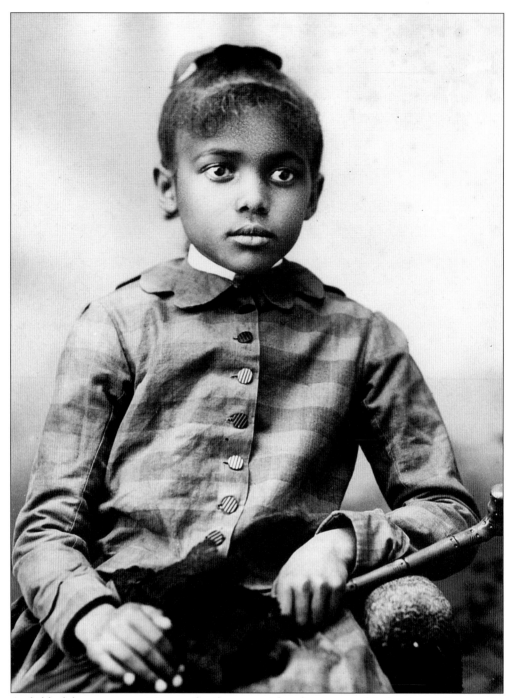

A child of the prominent Mazique family poses with a dressy parasol in her lap. Following the Civil War, the Maziques worked diligently to acquire land and other property and eventually became one of Natchez's most prosperous late-19th-century families.

Perhaps it was the photographer himself who was successful in catching the attention of young Purdy Enders and her brother Hunter.

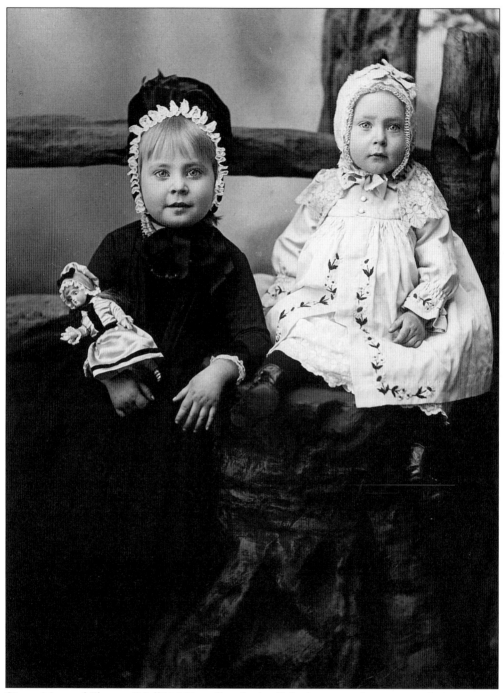

Sisters May and Eleanor "Nell" McDowell embody all the beauty and sweetness of a generation of children in this portrait made in the late 1880s. The girls were daughters of Seaborn McDowell, an accountant and a partner in the Franklin Street hardware store Baker and McDowell.

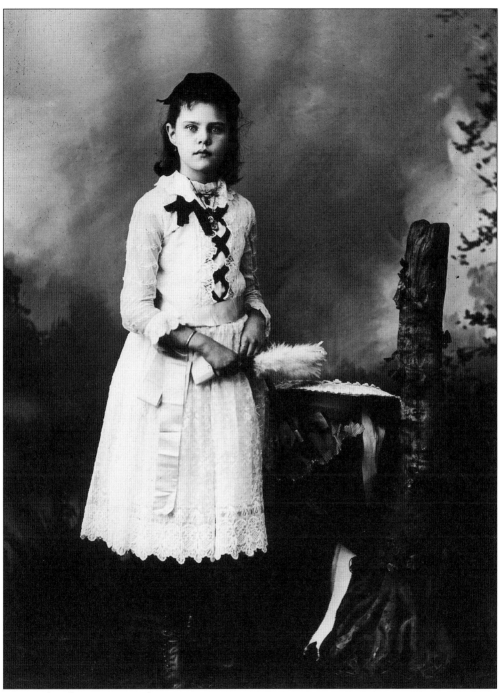

Kate Gabriella Burns was a beauty at age 11.

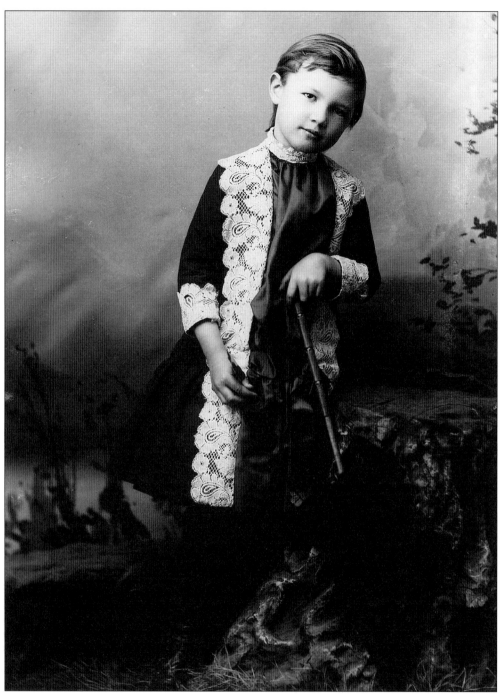

Annie Shotwell Green grew up to become an enterprising woman who, as a widow, operated her own business during difficult economic times. She was a leader in establishing the Natchez Pilgrimage and owned two historically and architecturally important Natchez mansions, Monmouth and Arlington.

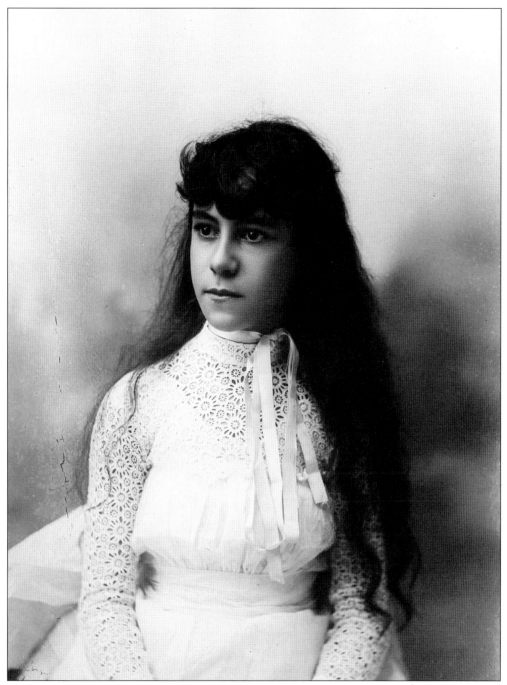

Agnes Schwartz, born in 1872, went on to become one of Natchez's most prominent philanthropists and charity workers. She married James Metcalfe and during much of her adult life volunteered her time for The King's Daughters Home, Associated Charities, the Natchez Cemetery Association, and the First Presbyterian Church. Her brother and sister are pictured on p. 10.

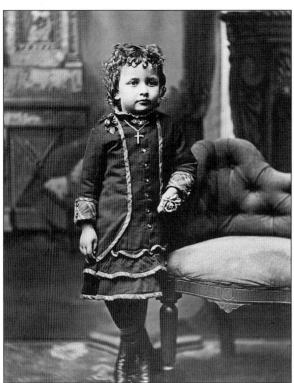

Zuelika Lawrence wears a stylish schoolgirl dress in the early 1880s.

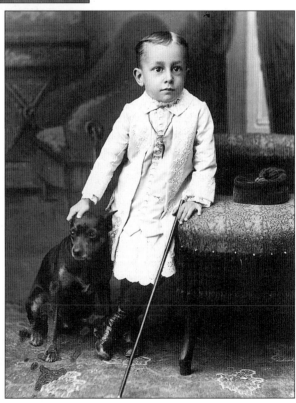

Photographed with his dog, Paul Albert Salvo in about 1886 is entirely elegant, from the collar pin on his richly trimmed suit to the handsome gold-tipped cane.

54

Richly dressed in a fur-trimmed velvet coat, Annie McNair, at right, traveled with her family from neighboring Jefferson County to have a portrait made by Henry C. Norman. Annie's father was Dr. Angus McNair of Fayette. Below, daughters of Allie Baker take turns posing with a favorite doll.

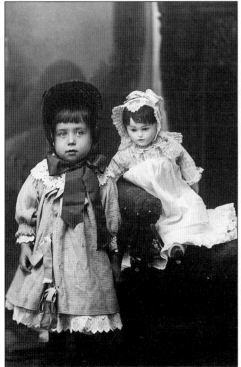

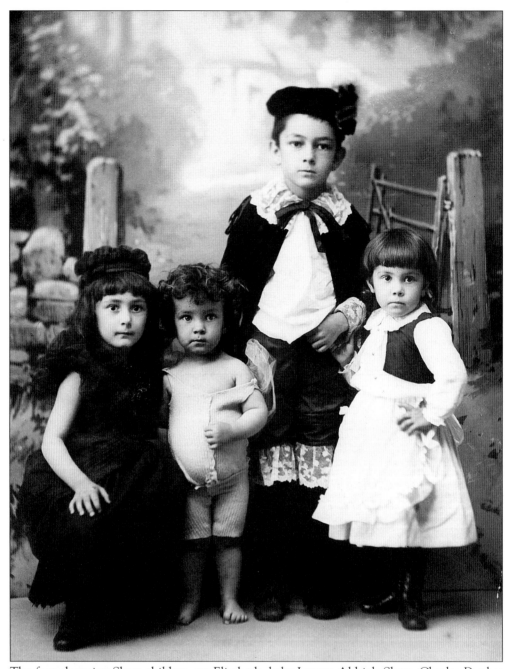

The four charming Shaw children are Elizabeth, baby Lyman Aldrich Shaw, Charles Dunbar Shaw Jr., and Mary in about 1893. A careful look at baby Lyman provokes many questions. Did he insist upon shedding his clothes, or was he not intended to be in the photograph in the first place? The slight twist of his mouth and curling under of his toes present unlimited speculations. So does the filmy pouf protruding from behind him. Is it a hastily made costume? Or did he perform in some marvelous Natchez entertainment—as Cupid, perhaps?

Three
THE 1890S

Props stand out in Henry Norman's portrayal of children in the 1890s. His use of toys and his attention to detail in position and expression provide a beautiful glimpse into childhood during the so-called Gay Nineties. Boys hauled bicycles to the second-floor studio. Mothers carted dolls, doll carriages, stuffed bears, extraordinary A-B-C blocks, and other equipages of childhood to the studio to embellish the photographs. And as one person put it many years later as she recalled having been photographed as a child by Norman: "He would just pose you and pose you until he thought it was perfect."

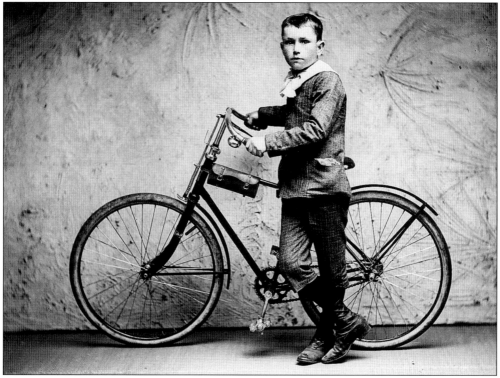

Every boy of the 1890s knew that bicycling was a "clean, healthful sport, and a wheel is good company," as stated in the September 6, 1892, edition of the Natchez *Daily Democrat and Courier*. This unidentified bicyclist has one of the new "safety" bicycles, which appeared in 1888 and took the "safety" label from the low and uniform back and front wheels which for the first time bore pneumatic tires. Most of the early safety bikes of the period cost about $100.

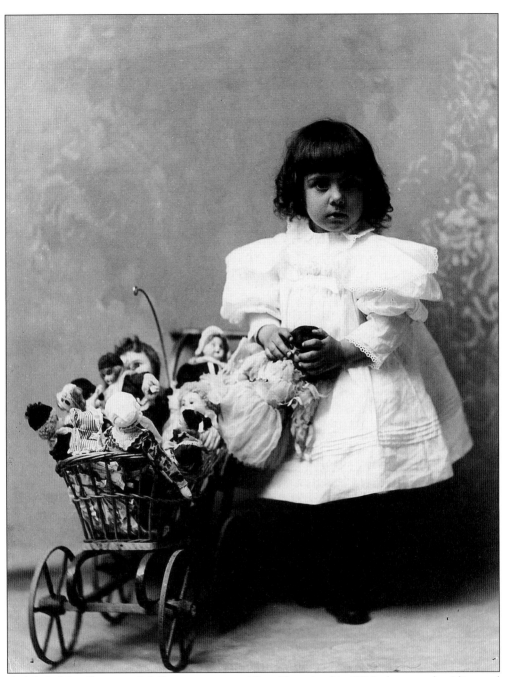

A delightful collection of dolls accompanies Alice Shaw in this 1895 photograph. Alice and her brothers and sisters, shown on p. 56, lived at Melmont, a beautiful antebellum house in Natchez, and at their grandparents' Louisiana plantation. Their father was a feisty steamboat captain who ran the local packet *Charles D. Shaw*.

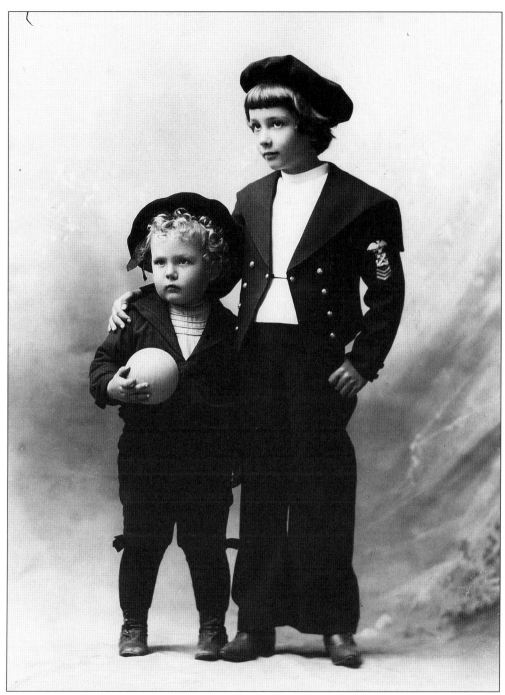

Audley B. Conner and his younger brother Lemuel, about 1896, are outfitted for a summer resort. These boys did, in fact, spend summers with their parents, Mary and Lemuel Conner, at Narragansett in Rhode Island. In 1895, the boys were featured in a promotional brochure titled, "A Sketch of Narragansett Pier and Its Delightful Attractions As A Water Place." Their father and their sister Eliza are on p. 88.

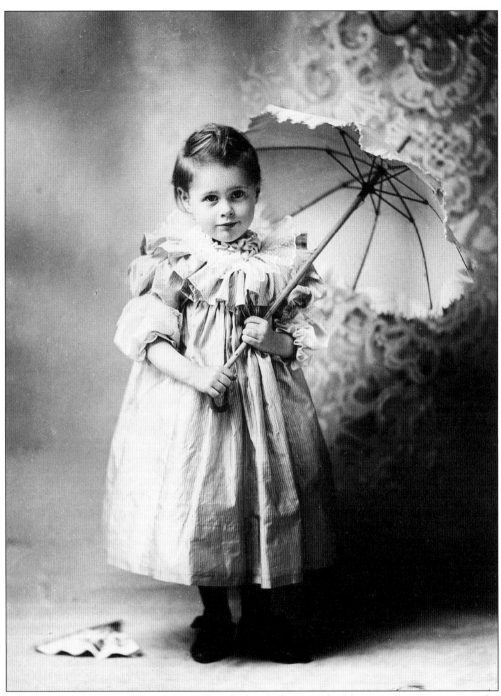

Ruffles frame the sweet face of an unidentified girl photographed by Henry C. Norman in the 1890s. Her engaging smile has made her a favorite among those who have viewed exhibitions of Norman's photographs of children. In the 1890s, Norman began using the convenient dry-plate negative, which hastened the once painfully slow process of creating the photographic image.

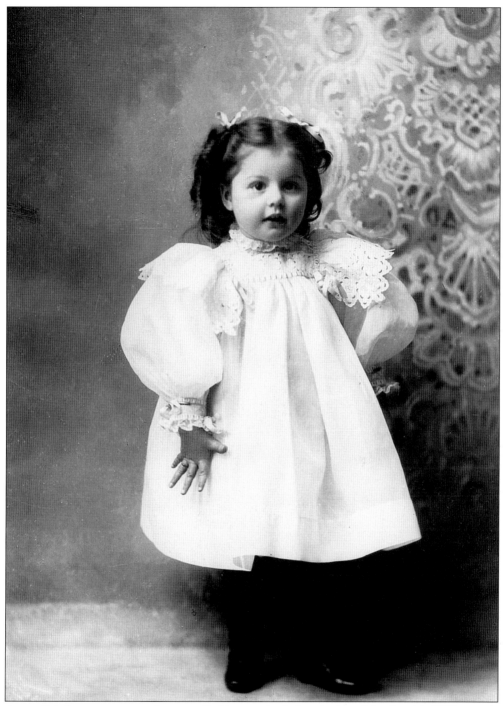

Annet Pritchartt many years later recalled her mother's description of the day this 1898 portrait was made. "Mr. Norman, I want a pretty picture," Mrs. Pritchartt said. The photographer replied dryly, "Madam, if the child is pretty, the picture will be pretty." The mother need not have worried. As for the child, she grew up to become one of Natchez's best and sternest high school mathematics teachers.

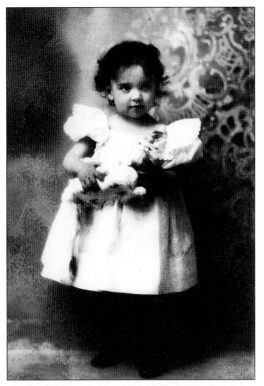

Katherine Grafton, at left, grew up to marry Balfour Miller, pictured with his brother on p. 98. From the 1920s until their deaths, they lived at Hope Farm. Katherine was a major organizer of the Natchez Pilgrimage in 1932 and continued to be a forceful community leader for many years following. At right below is a child in the Burke family. At left is Ruth Barbara Eisele, who left Natchez to become an educator in Gulfport. Ruth's brothers are pictured on p. 25.

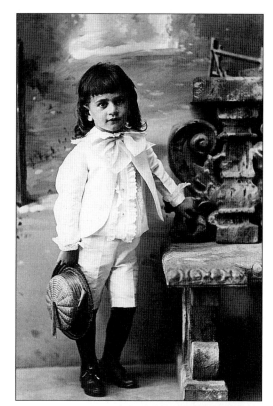

At right is Palmer Lanneau, showing the popular curls boys wore in the 1890s. Both boys below are unidentified but stand out among Norman's portraits of children because of their outfits and dignified demeanors.

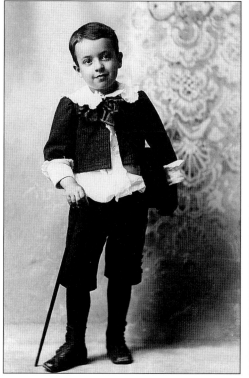

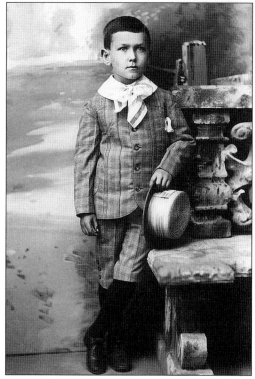

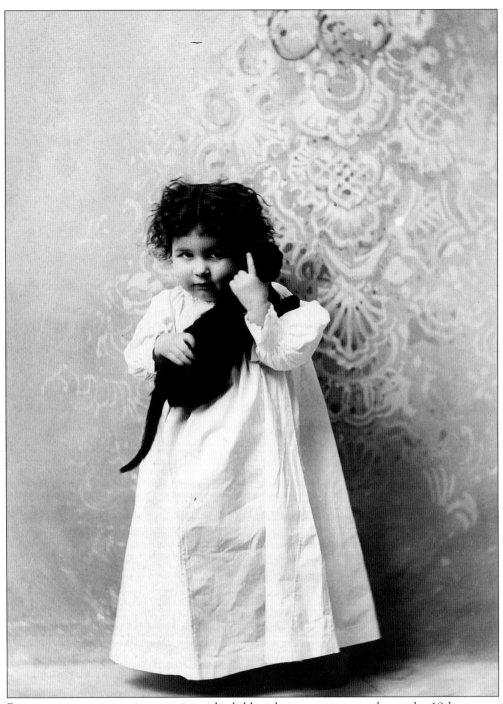

Bringing pets to appear in portraits with children became more popular as the 19th century came to a close. This unidentified girl holds her pet cat affectionately.

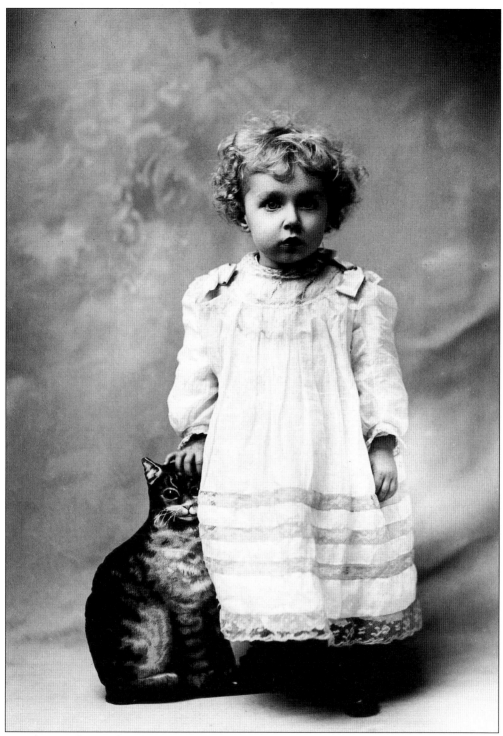

For this unidentified toddler, a make-believe cat appears a suitable companion for the photograph.

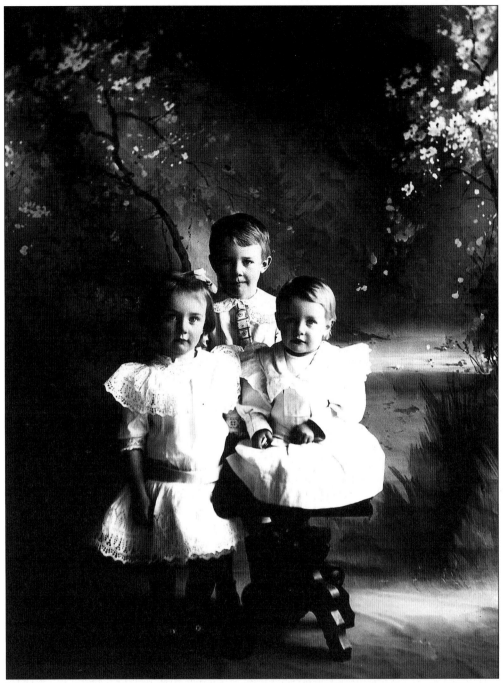

The children of S.B. Benton of nearby Rocky Springs pose for Henry Norman in the 1890s in a portrait which beautifully demonstrates the photographer's expertise.

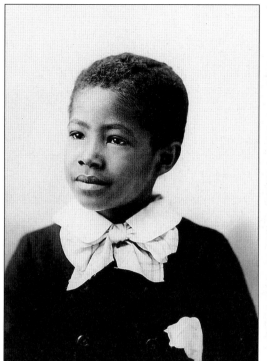

Left: Young Mr. Banks wears a big soft tie and matching handkerchief. *Right:* Jack Limerick wears a stylish checked suit and flat ribbon tie.

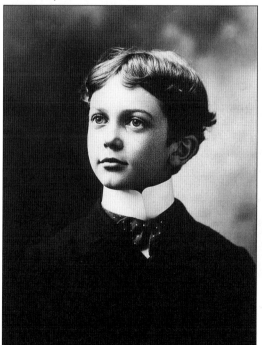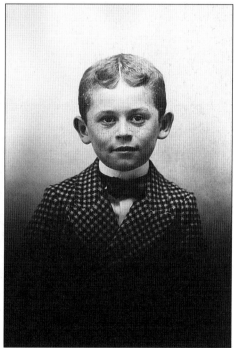

Left: Charles Patterson wears a high stiff collar and patterned tie. *Right:* Francis Farrell wears a bold checked suit and bow tie.

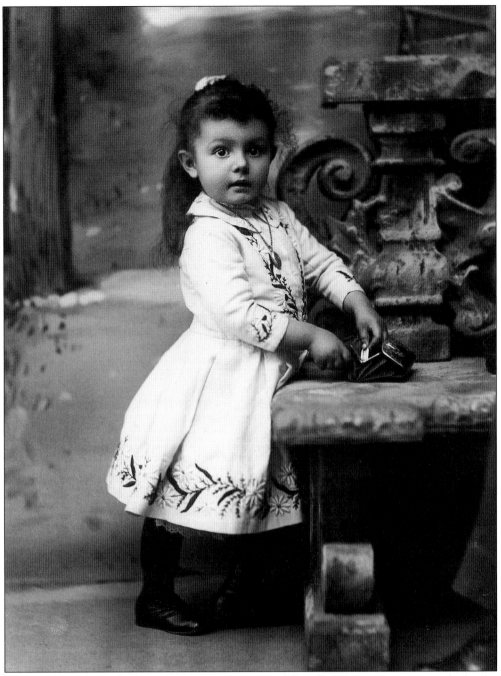

With a coin purse perhaps used for distraction, an unidentified little girl poses prettily for the photographer in about 1890.

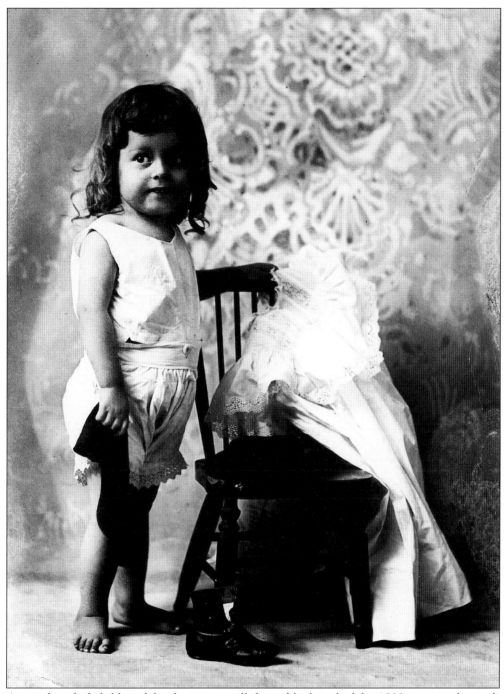

An unidentified child models what every well-dressed little girl of the 1890s wore underneath her summer garb.

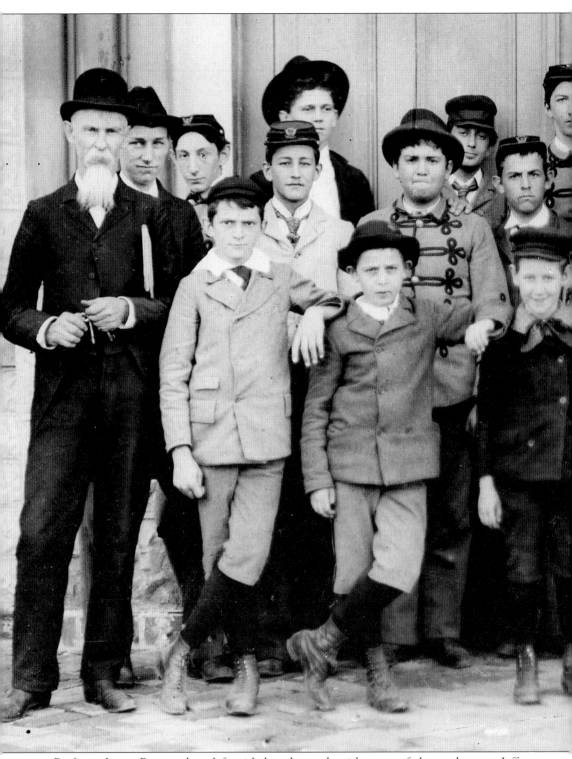

Professor James Raymond, at left with beard, stands with some of the students at Jefferson College in about 1895. Alan Montgomery, in uniform, stands in the middle of the back row.

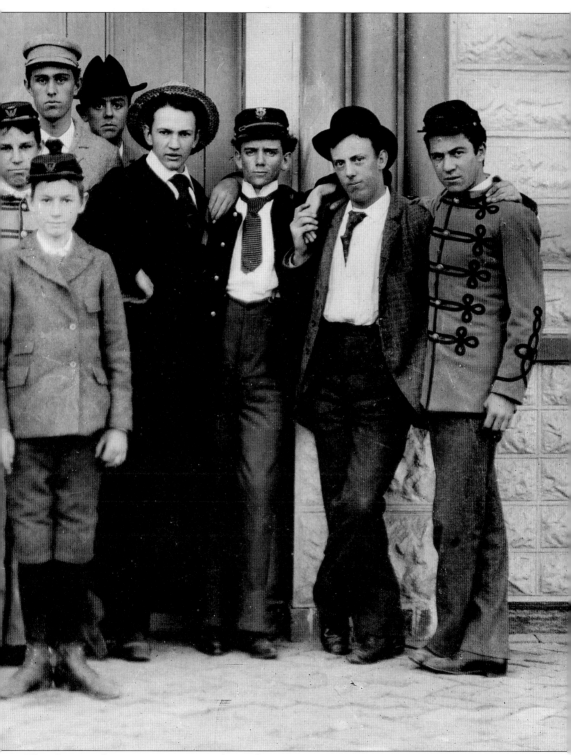

The photographer's youngest son, Earl, stands center front in the dark suit.

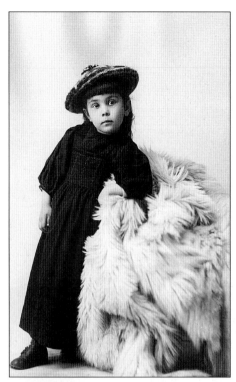

Mary Shaw, at left, wears a fashionable wool hat in the tam-o'-shanter style. At left below Miss Payne poses about 1890. At right below Lyman Aldrich Shaw sits on his wonderful tricycle in about 1895.

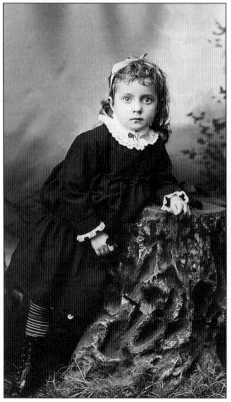

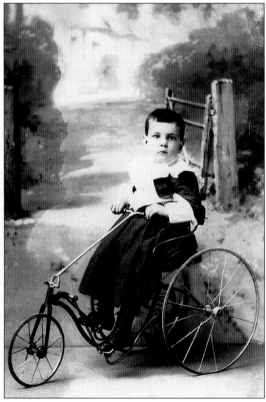

The little carpenter at right is a favorite among those who have viewed exhibits of Norman's portraits of children. His open, direct gaze is captivating. Sad to say, he is unidentified. At left below is one of the Breithaupt boys, perhaps William. And below at right is Edwin Benoist, who grew up to become one of Natchez's prominent physicians for many decades of the 20th century. Twins Caroline and Percy Benoist, pictured on p. 93, are his younger sister and brother.

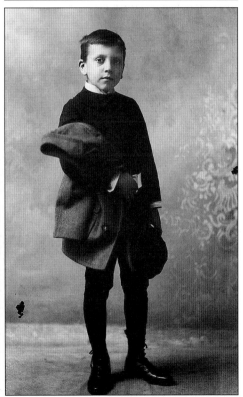

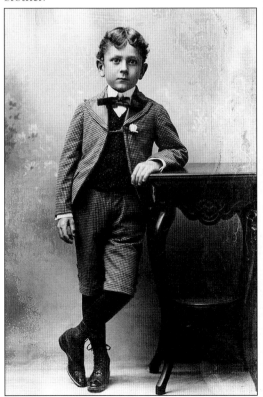

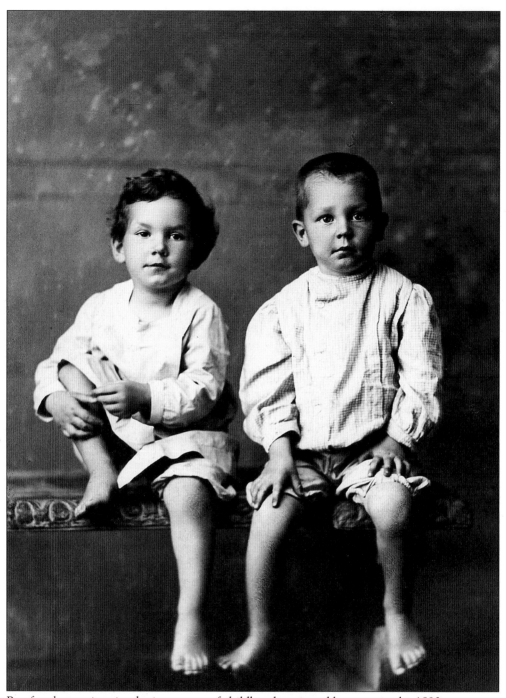

Barefoot boys epitomize the innocence of childhood as viewed by many in the 1890s.

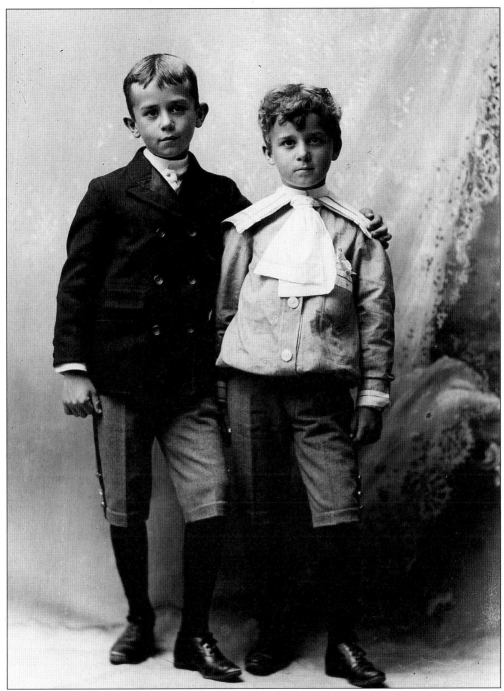

Dunbar Surget Merrill stands with his younger brother, Aaron Stanton "Tip" Merrill, about 1898. As youngsters, they rode horseback from their palatial home, Brandon Hall, located near the Natchez Trace, to a one-room country schoolhouse. Tip, here looking very much the apple of his brother's eye, was graduated from the Naval Academy in 1912; he attained the rank of vice admiral at the end of a long and distinguished career and was honored posthumously by the commissioning of a United States Navy destroyer named in his honor.

At left, an unidentified boy casts a forlorn look as he poses bravely in his stylish sailor suit and hat. Below at left, another unidentified child shows off a handsome example of a hand-trimmed two-piece suit worn by many toddlers of the period. Below at right, Morrell Feltus holds hands with a favorite stuffed bear. Morrell grew up to become a champion marksman, and won several national titles.

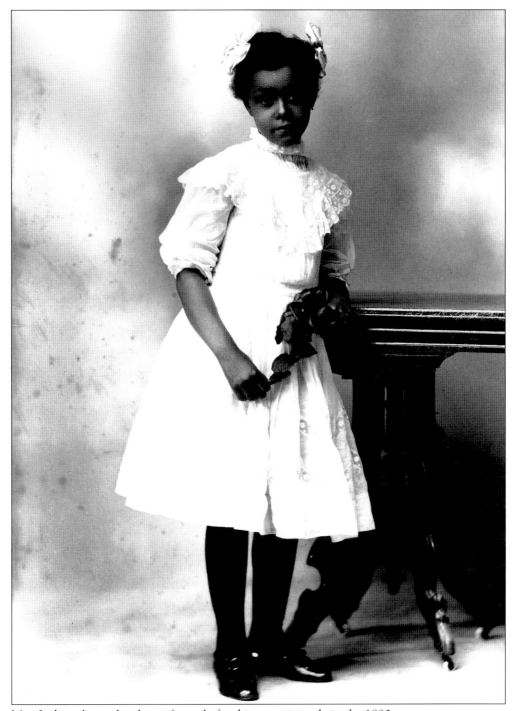

Miss Jackson has only a hint of a smile for this portrait made in the 1890s.

Miss Koerber wears a smile to match the bold outfit of checked coat and dress and large straw hat.

Backdrops and props used in the studio of Henry C. Norman apparently changed about every ten years. Some exceptions are obvious to the careful viewer. However, with identifications of people in photographs and therefore pinpointing of the dates the photos were made, groupings of studio furnishings and accessories fall into chronological place easily. What's more, the photographer experimented with poses and other techniques which are interesting to follow from one decade to another. But for the winter outfit of one and the lacy white dress of the other, these two unidentified girls, posed in similar positions, look as though they might have stood for their portraits one after the other on the same day.

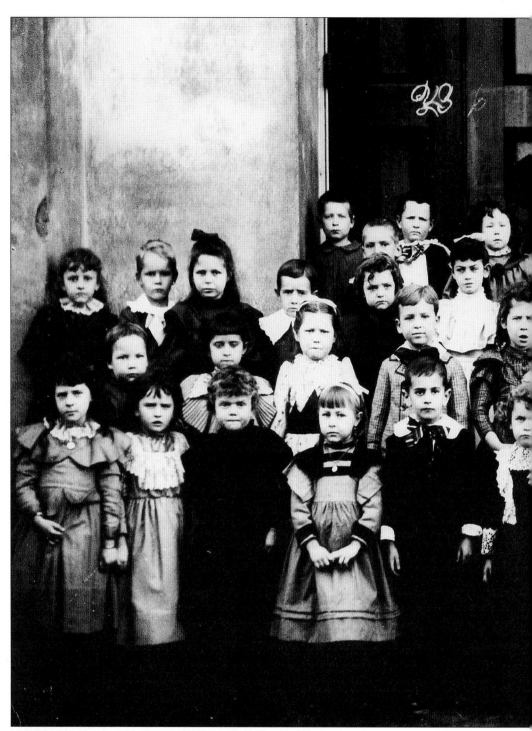

Natchez Institute teacher Jennie Stietenroth and one of her young classes pose in 1895. Among the students in the class are the photographer's youngest son, Earl Norman, at right about three rows from the top at the end of a row and wearing a large dark tie. The Natchez Institute, a public school, was built before the Civil War. After the war, in 1871, the Union School was

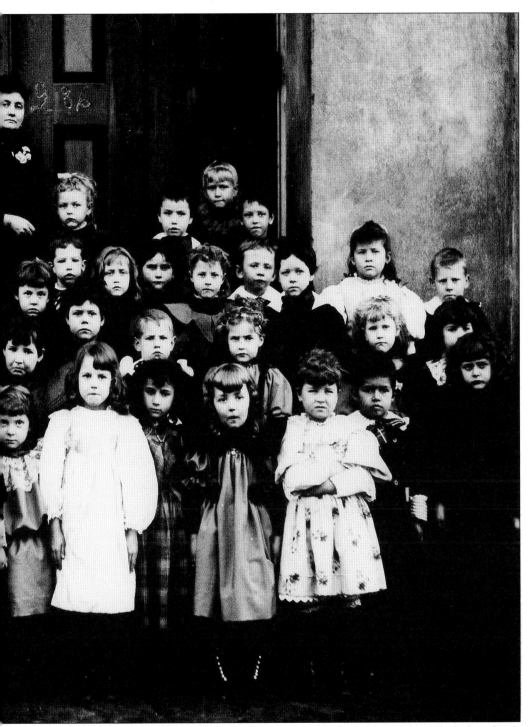

constructed, the first Natchez public school opened for black children. Three Catholic schools operated in the city during the post-war years, one especially for black children. Many private schools offered classes, too, such as Dr. Purviance's School, Miss Buckner's School, Mr. Thomas Henderson's School, Mrs. Field Dunbar's School, and Mr. A.D. Campbell's School.

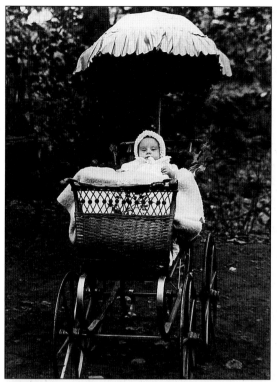

Henry C. Norman traveled around town with his camera and made many thousands of images on front porches, street corners, steamboats, and theater stages. His photographs of rural life and Mississippi River life are among the finest made during the late 19th century. Norman was on one of his outdoor assignments or joy walks when he made the photograph at left of an unidentified baby in a very fine buggy. Below, young Rawle Martin, sitting in a stylish walker on rollers, was one of the twin sons of Ethel Rawle Martin and Farrar Conner Martin. Both boys died at young ages, one of diphtheria and the other of scarlet fever.

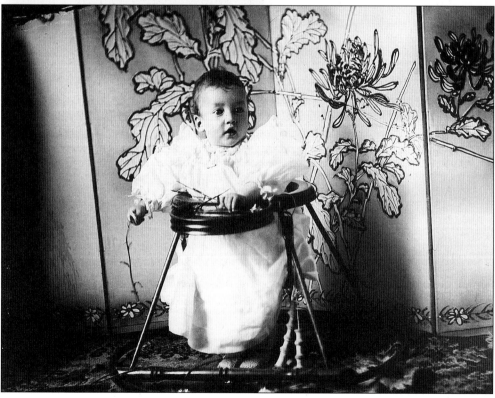

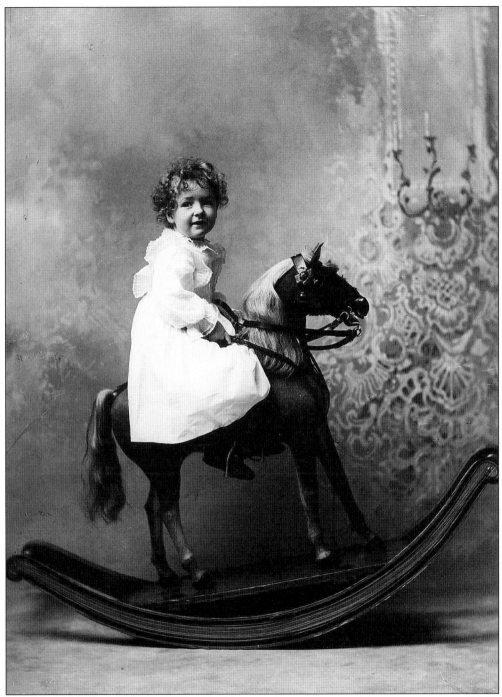

Melchior Roch Beltzhoover smiles with delight as he rides a very fine rocking horse in 1895. Melchior married beautiful Ruth Audley Wheeler, pictured on p. 97. They lived with their children in the famous Natchez mansion Green Leaves.

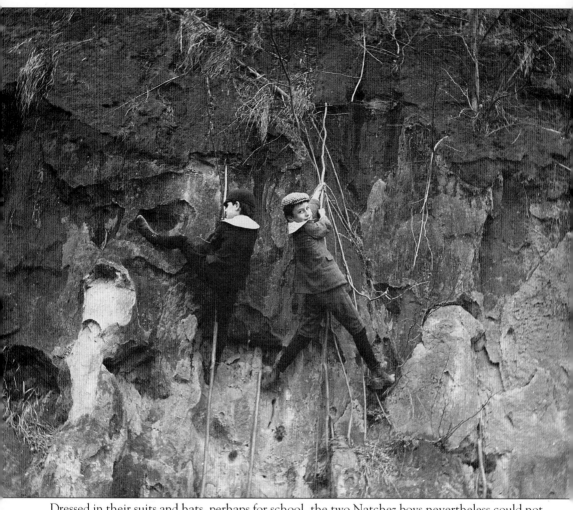

Dressed in their suits and hats, perhaps for school, the two Natchez boys nevertheless could not resist a climb on one of the many bluffs for which the Natchez landscape is noted.

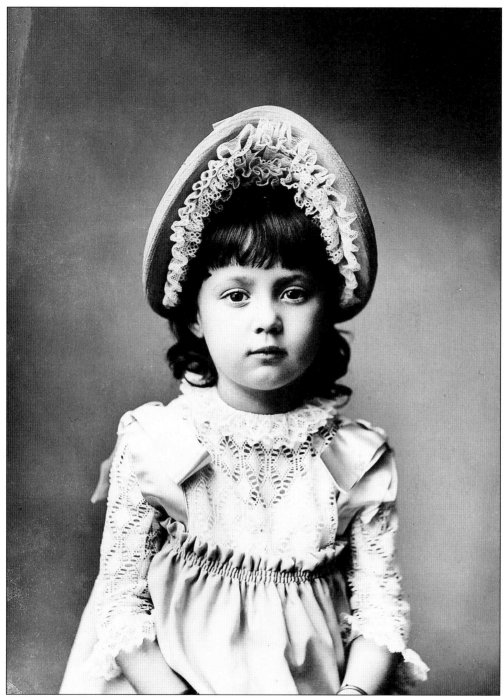
A picture of femininity, Miss Farish wears a beautifully trimmed dress and hat.

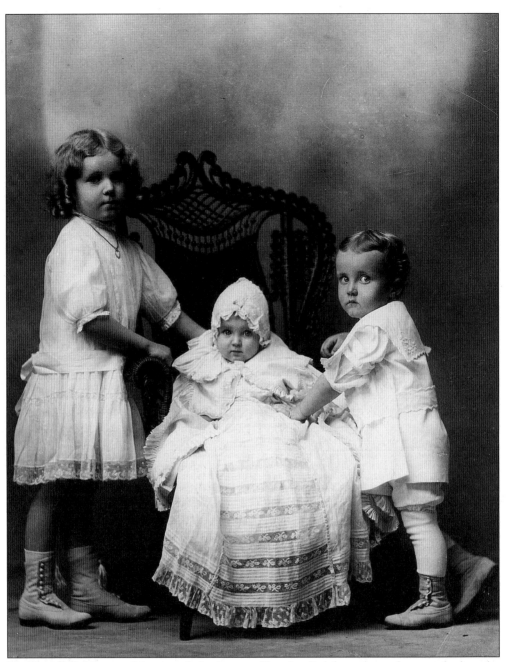

The Persell children are Margaret, baby Ann, and brother Ralph, perhaps photographed on the occasion of Ann's christening. The children lived at a large antebellum house named The Towers. Margaret, who married George Marshall and lived at the Marshall family home, Lansdowne, was a founder of the Natchez Pilgrimage and active in Natchez society throughout much of the 20th century.

Four

THE EARLY 1900S

The Victorian era did not end abruptly with the death of Queen Victoria in 1901 any more than the turn of the new century heralded any significant variances from American life as it had been known in the 1890s. Yet, for children, the gradual changes that had been evolving since the end of the Civil War reached important high points in the early 1900s, with national attention focused more and more on their education and general welfare. Parents, still for the most part Victorian, clung to some styles and ideals popular in their own childhoods, but the end of an era was at hand. The last of the Victorian children grew up to face a world war and technological advances that precluded innocence and naiveté. Knowing today what was before them, as they could not have known then, lends to the photographs of these last of the Victorian children perhaps the ultimate in nostalgia toward that golden age of childhood.

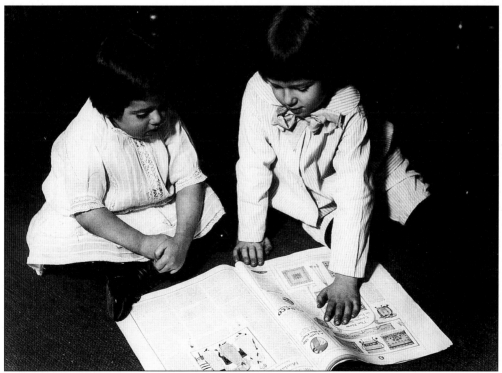

Unidentified children read an issue of *The Ladies Home Journal* in about 1915. The magazine, then about 30 years after its initial publication appeared, continued to influence fashion and home life as children of the early 1900s came along.

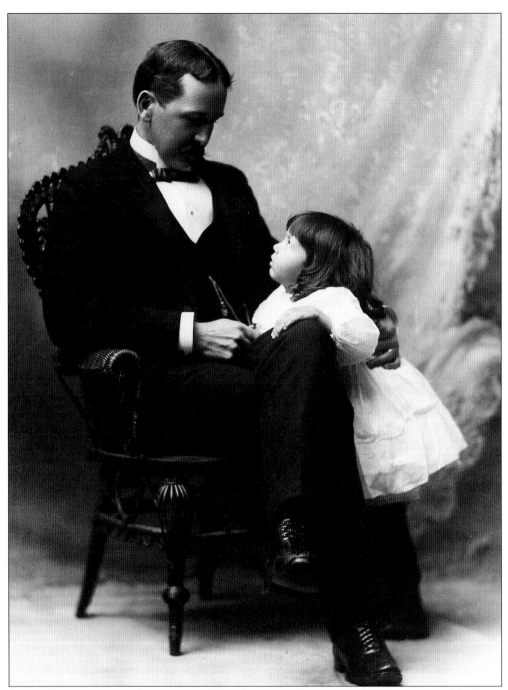

Lemuel P. Conner and his daughter Eliza share an affectionate gaze in about 1900. Eliza's mother, Mary Britton Conner, was among Natchez's first preservationists. In the 1930s, Mrs. Conner wrote identifications on many of the 19th-century negatives made by Henry C. Norman. Moreover, she was one of the early amateur photographers in Natchez, and she kept voluminous scrapbooks chronicling social and political life in Natchez for several decades. A picture of Mrs. Conner when she was a young girl appears on p. 112.

Ruth Britton Wheeler and her son Britton pose in beautiful summer dress typical of the turn of the century. Mrs. Wheeler's daughter Ruth Audley is on p. 97.

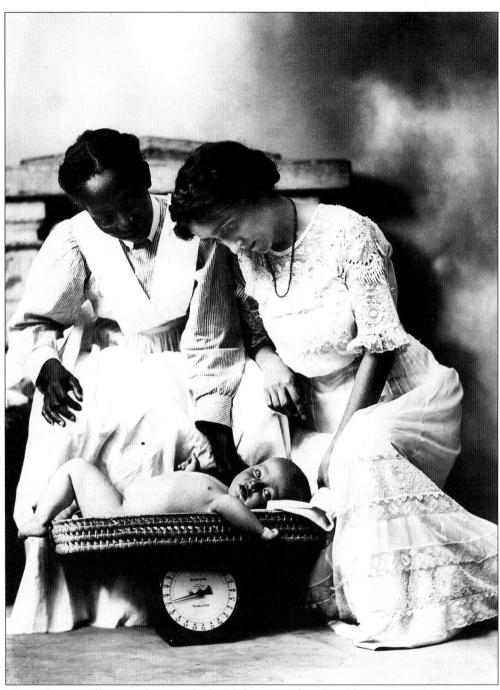

Eliza Schwartz Allee was photographed with her son Edward and his nursemaid in 1908, one year after Congress officially declared a day set aside to honor mothers—Mother's Day. Eliza's ill-fated sister Kate is pictured on p. 96.

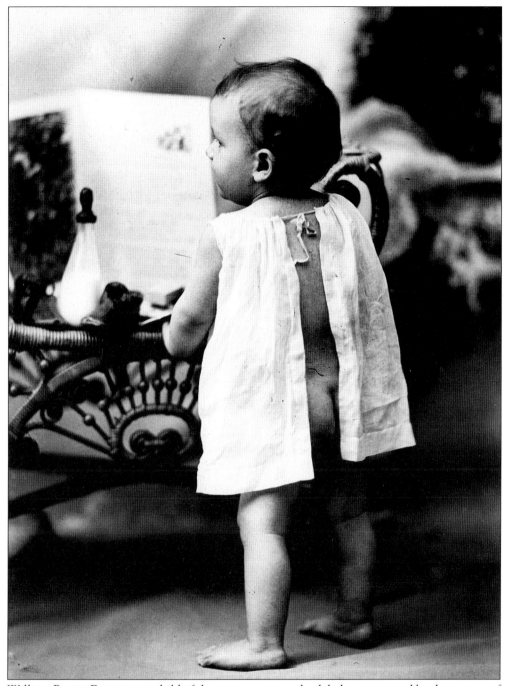

William Baxter Fraser was a child of the new century and a delight as captured by the camera of Henry C. Norman in 1900. Little William's pose, gown, bottle, shoes, and book create a gem of a picture.

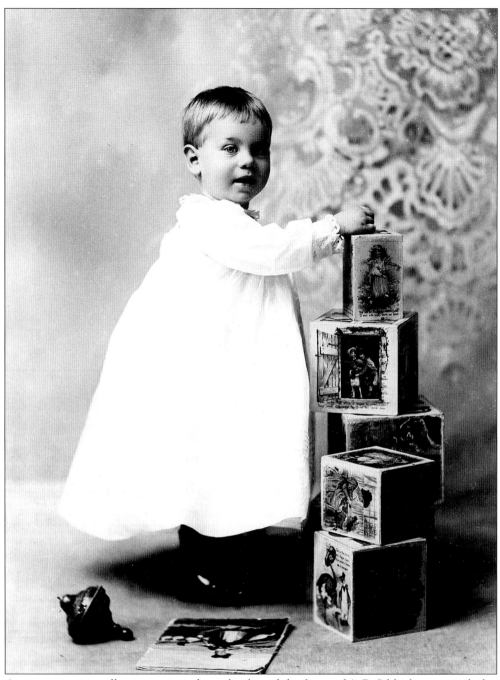

A spinning top, a well-worn nursery rhyme book, and the finest of A-B-C blocks went with this little one to the photographer's studio.

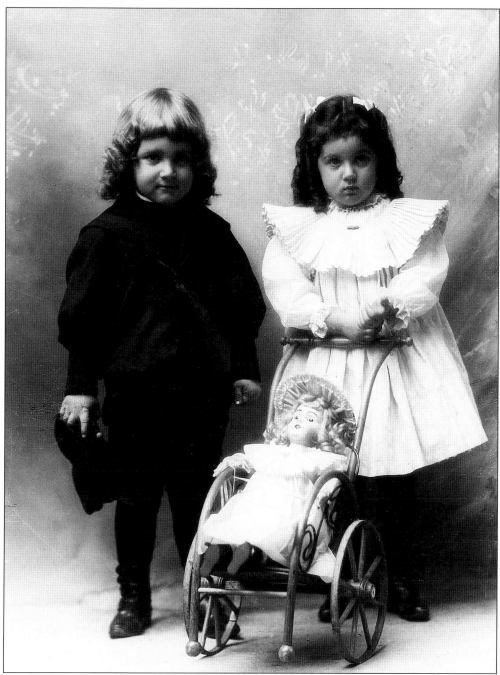

Twins Percy and Caroline Benoist, about 1900, epitomize the enchanting attraction of children—beauty, sweetness, and candor. Percy served in World War I and entered the family's Main Street clothing business. Caroline went on to Johns Hopkins for a nursing degree, graduating in 1925. In her later years, however, she also worked in the family business and continued to live in the family home on South Union Street. Many identifications made for *Natchez Victorian Children*, the 1981 book upon which this publication is based, were made through Caroline's tireless efforts.

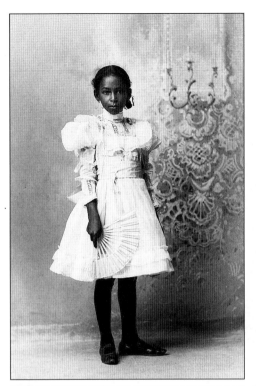

Fans and parasols were popular props, as shown in three portraits made about 1900. At left is Miss Walker, stylish in her dress with leg-of-mutton sleeves. Below at left, an unidentified girl poses with a fine parasol. Below at right, Mary Thomas Burns poses with a frilly parasol, a fan, and a lace handkerchief. Such accessories do not appear as frequently in photographs made by the time of World War I and after.

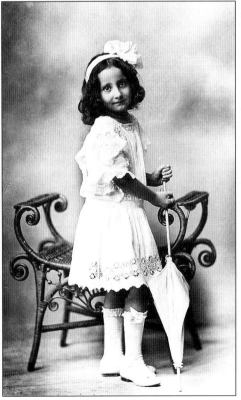

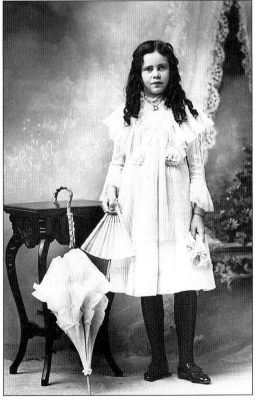

Three versions of dresses for little boys show the continued preference of mothers in dressing their small sons. At right is Arlie Chandler Warren, who went on to spend most of his adult life as a public servant in Natchez. Below at left is Walter Bahin, who was prominent in law enforcement during his lifetime in Natchez. Below at right are Gerard Brandon and his sister Ethel. Gerard became one of Natchez's most prominent 20th-century attorneys.

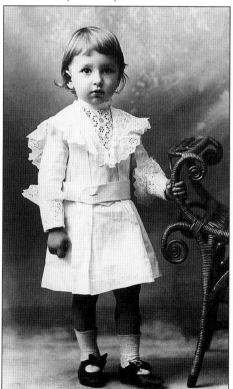

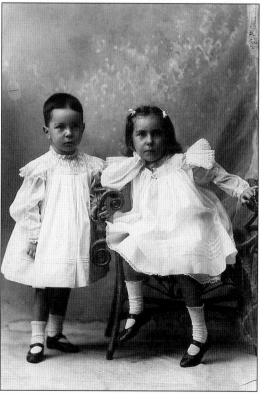

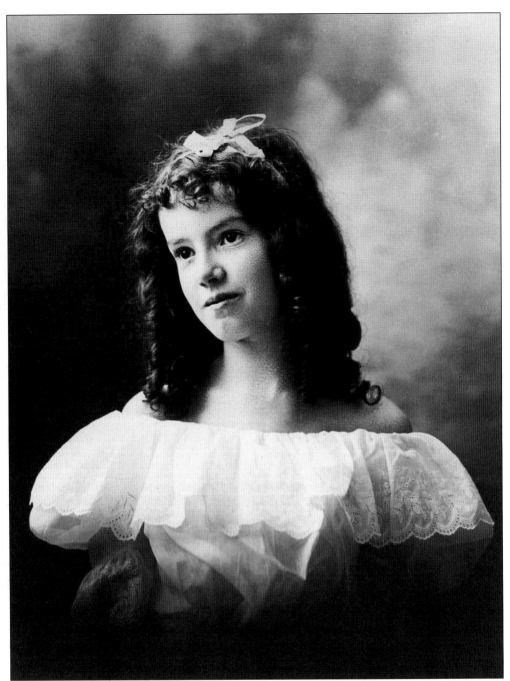

Kate Schwartz, photographed about 1900, was known for her beautiful long auburn curls and her expressive eyes. She was never to know the end of the era of which she was a part, however. She and her fiancé, Charles West, were drowned in a boating accident in the Mississippi River in 1911. Kate was 21; her fiancé, 22. They are buried beside each other at the Natchez City Cemetery.

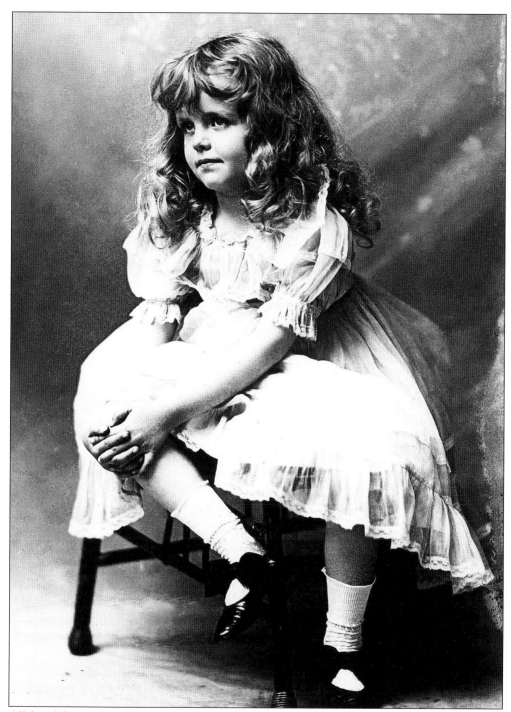

All her life a style-setter and a charmer, Ruth Audley Wheeler poses in about 1900. Ruth Audley became a successful businesswoman, operating a popular clothing and department store for many years. A founder of the Natchez Pilgrimage, she was prominent as a social and civic leader through much of the 20th century.

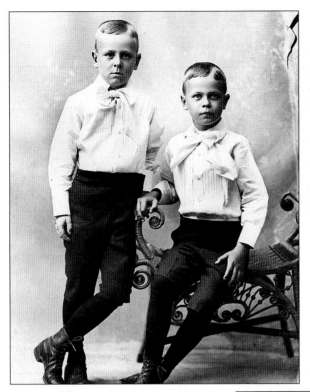

Balfour Miller, seated, and his brother Bayard share a serious moment in front of the photographer's camera about 1903. Even as a boy of 16, a few years after this picture was made, Balfour showed great promise, receiving a gold medal engraved "With Excellence" upon his graduation from high school. Balfour's business successes included pioneering oil exploration in areas near Natchez. A poet, too, his collection of poems, *Poems and Miscellany*, was published in 1978, the year of his 86th birthday.

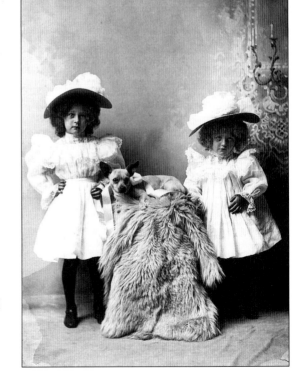

Sisters Cora and Lillian Ratcliff, charming in their matching dresses and fancy hats, give their pet dog the place of honor on a fur-like blanket used frequently in Henry C. Norman's photographs of babies.

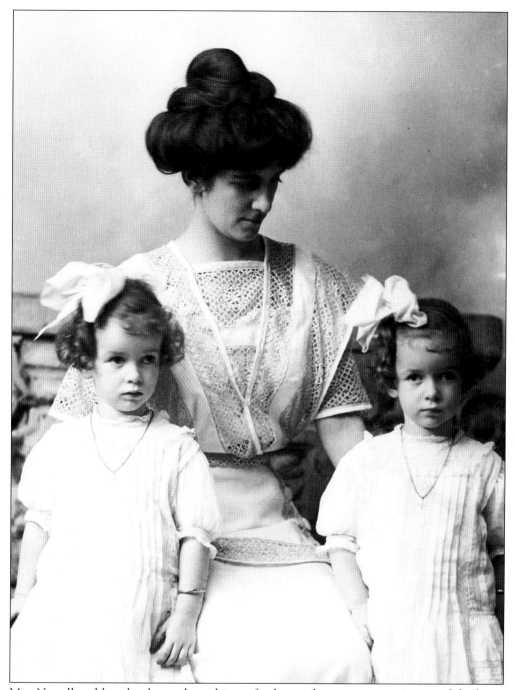

Mrs. Newell and her daughters, dressed in perfectly matching attire, are pictures of the latest feminine styles for the early 1900s.

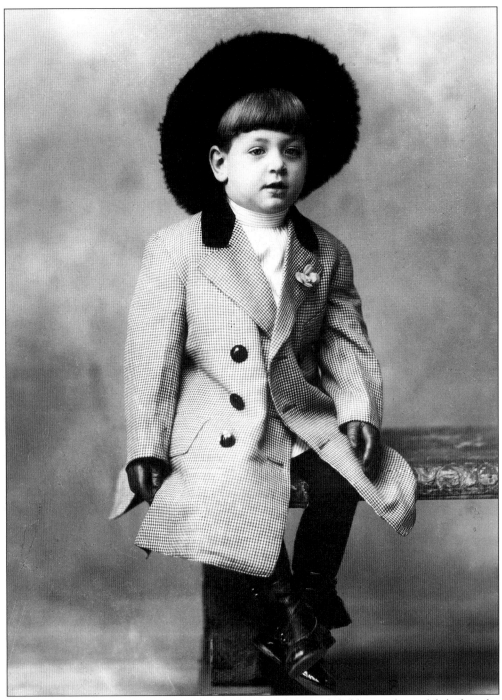

James McClure, about 1914, was among the last generation of children to know life before the great world wars.

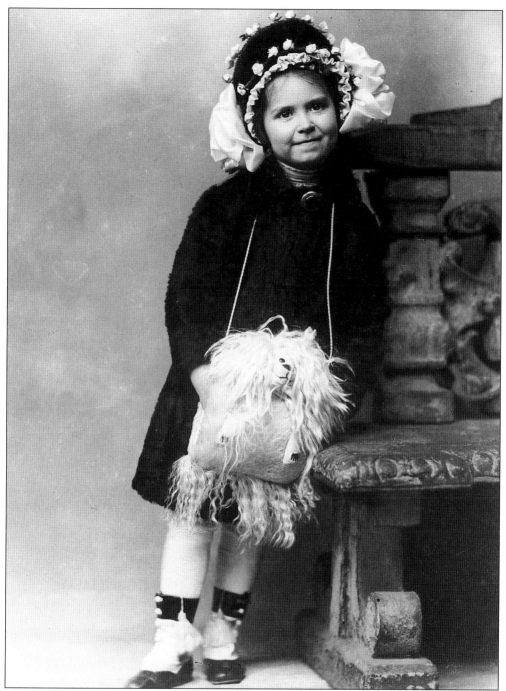

Mary Louise Netterville, outfitted beautifully with her fancy hat and muff, grew up to become a prominent businesswoman and social and civic leader in Natchez. During the middle years of the 20th century, she was Mississippi's Democratic Party national committeewoman. As a founder of the Natchez Pilgrimage and owner of the antebellum mansion Monteigne, she welcomed prominent state and national political figures to her home throughout the 20th century.

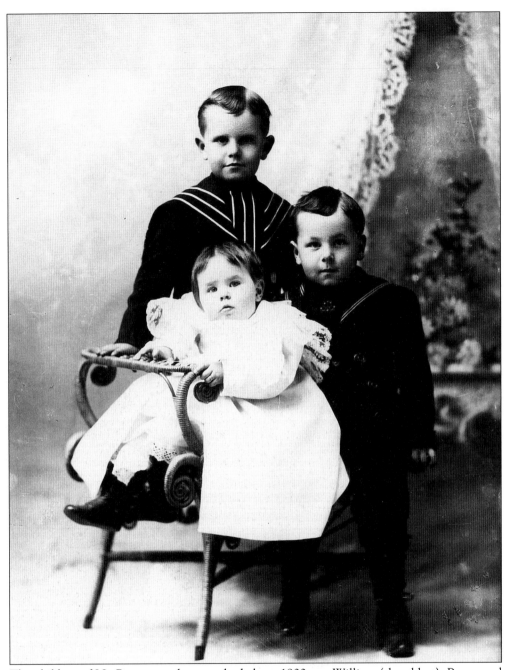

The children of J.L. Rountree, photographed about 1900, are William (the eldest), Percy, and Lucille. J.L. Rountree in 1882 bought the Vidalia, Louisiana, *Eagle* newspaper and changed the name to the *Concordia Sentinel*. First teaching the boys the newspaper business, he set up William as operator of the Madison Parish *Journal*, Percy at the *Sentinel*, and a nephew, Joe Scott, at the Tensas Parish *Gazette*.

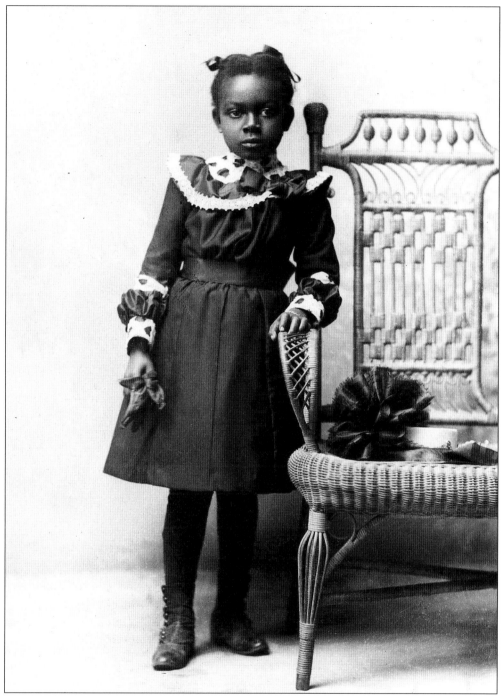

Her wonderful hat sits unworn in the chair, but this unidentified young lady puts her best serious expression forward for the photographer in about 1905.

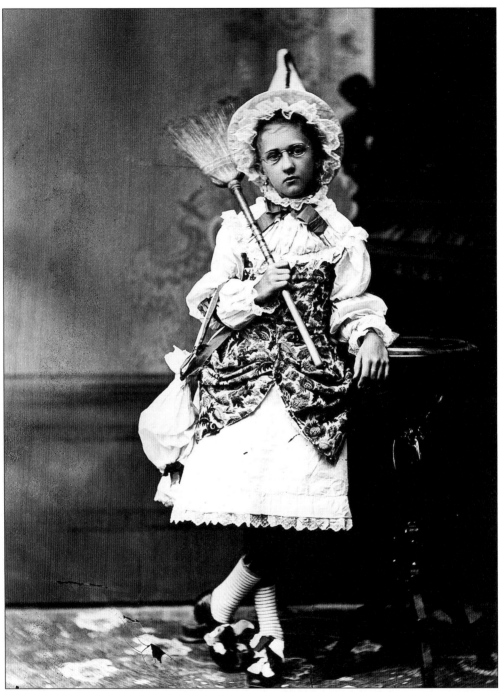

Agnes Stanton wears her costume for the "Broom Drill," an entertainment started in 1882 as a benefit for the local orphanage. As described by the daily Natchez newspaper, the young ladies went through military maneuvers "with that great weapon of female warfare," the broom.

Five
CELEBRATIONS

Dressing up to celebrate special occasions or to dabble in the world of make-believe did not originate with the Victorians nor did it end with them, but the Victorians were the first to have the opportunity to capture the splendor of the special occasion in a photograph. Judging from the remarkable photographs of costumed children in the late 19th century, it would seem that dressing up perhaps did reach a peak with Victorians—certainly with those in Natchez, who thrived on celebrations and delighted in make-believe. Mothers subscribing to Godey's magazine might read each month the "Juvenile Department," where entire tableaux for children were laid out, right down to stage setting and costumes. In addition, there were Mardi Gras pageants and extravaganzas such as "The Kermiss," in which children dressed up to take part alongside adult revelers and thespians.

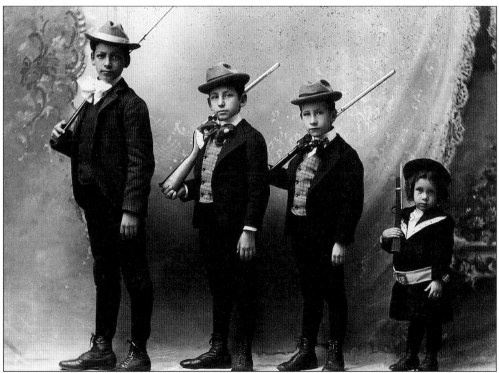

The Geisenberger brothers—Alex, Maurice, Clarence, and the youngest, Robert E. Lee Geisenberger—demonstrate the patriotism which swept the nation around the turn of the century.

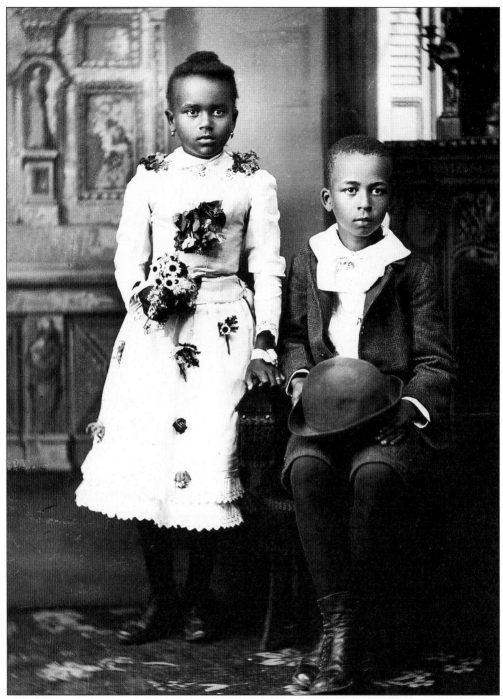

Two Mazique children, probably brother and sister and members of the prominent Alex Mazique family, pose as they might have appeared in a school or church function in 1885.

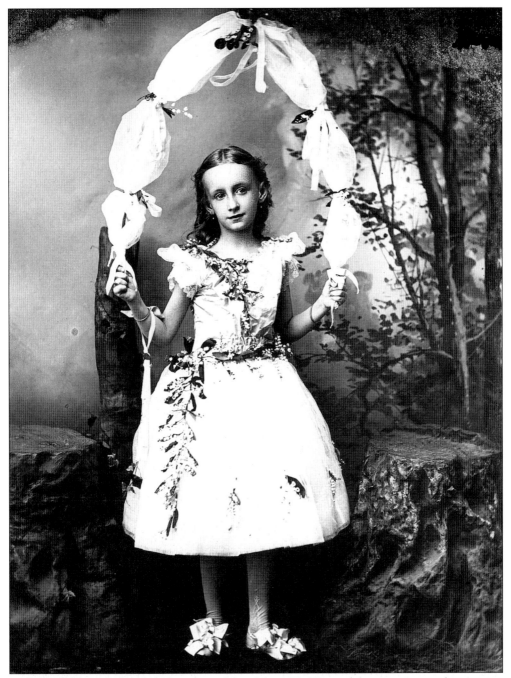

Mary Rumble poses about 1888, perhaps dressed for a May Day celebration—a popular event in the late 19th century. Mary grew up at her family's home, the famous mansion Rosalie. She never married, and, with two unmarried sisters, Annie and Rebecca, she remained at Rosalie until her death.

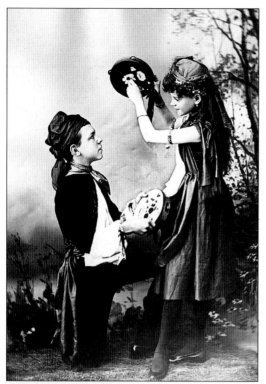

In 1887, Natchez socialites organized a lavish entertainment called "The Kermiss," a pageant in which many nations of the world were represented by costumed participants, who demonstrated in dance or pantomime some cultural characteristics of the various countries. Men, women, and children took part, and, thankfully, many of them went to Henry C. Norman's studio to be photographed in their amazing outfits. At left are young Theodore Wensel and his sister Sallie in Kermiss fashions. At left below is Vernon Reber, who was attendant to the Kermiss queen, Mary Britton. At right below is Josephine Tillman, daughter of businessman and sheriff Cassius Tillman, believed to be outfitted for the famous pageant.

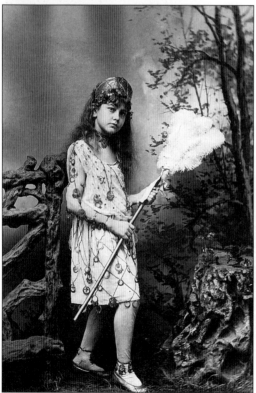

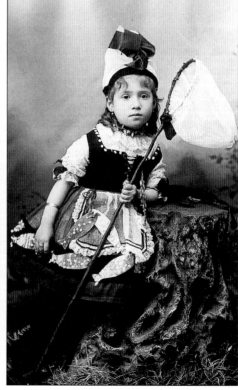

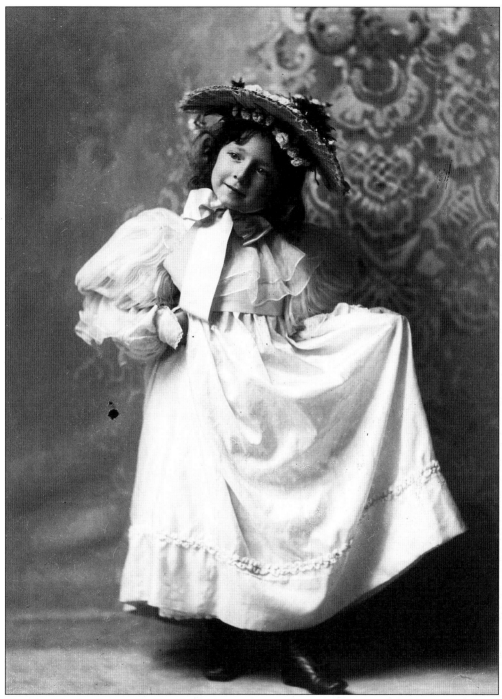

Dorothy Rhodes shows off a fine dressy costume topped by a stylish straw hat.

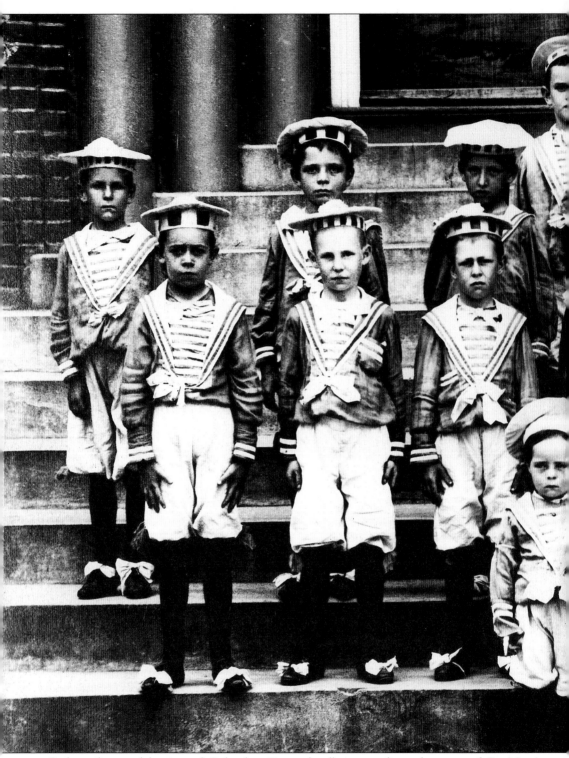

Perhaps for a celebration of Columbus Day, schoolboys stand on the steps of St. Mary's Cathedral. Christopher Columbus poses in the center of the group; the youngest sailor,

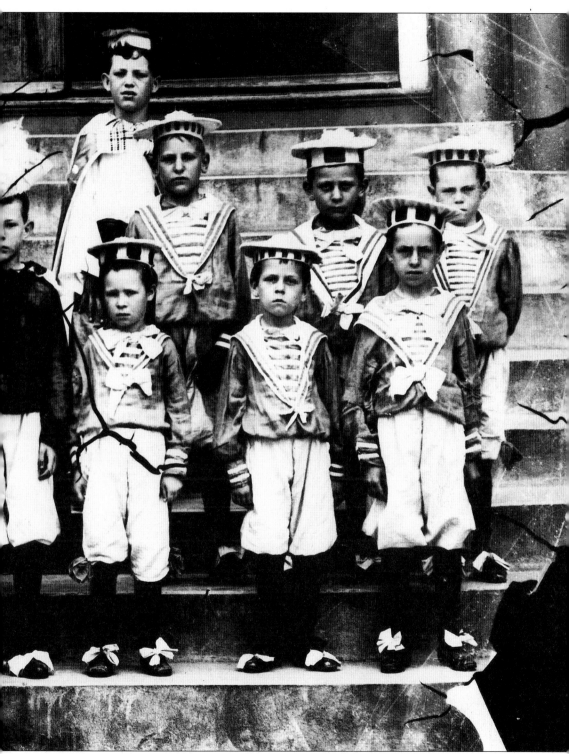

obviously unhappy with his lot, stands utterly alone in front pointing his index fingers at the unloved bows on his shoes.

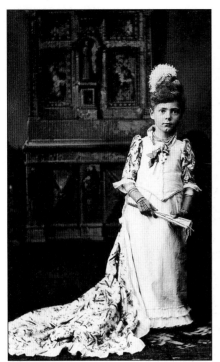
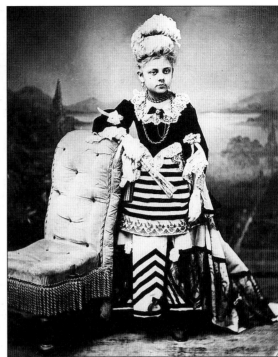

Left: Miss Byrnes poses in the 1880s. *Right:* Mary Britton, 1870s, models a fine costume.

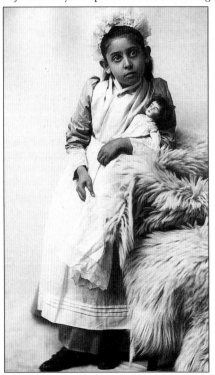
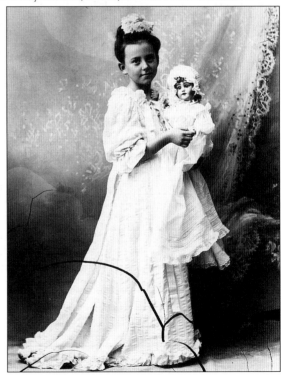

Left: Miss Thomas and her doll wear equally interesting costumes. *Right:* Anne West poses in about 1898.

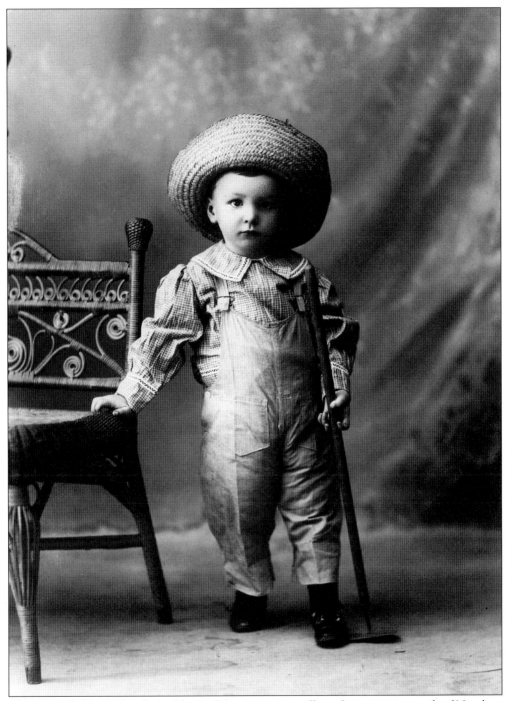

The Bates child, 1907, is from Gloster, Mississippi, a small rural community south of Natchez. Because most young men of this era left the family farms to seek fortunes in towns and cities, perhaps there is more significance—and nostalgia—to the photograph than meets the eye.

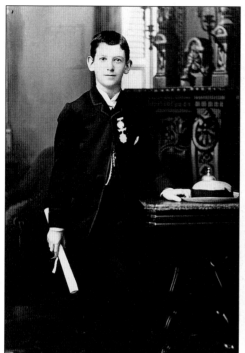
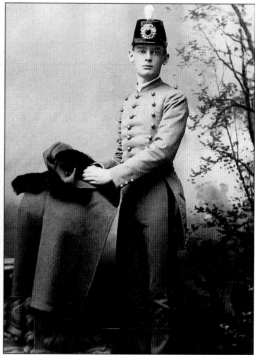

Left: Leon Meyer shows off his gold medal for oratory, won in 1887 and presented that year at the 85th graduation exercises of Jefferson College. *Right:* Edward Middleton Jr., splendid in his uniform in the 1880s, stands for his portrait during a visit home from military school.

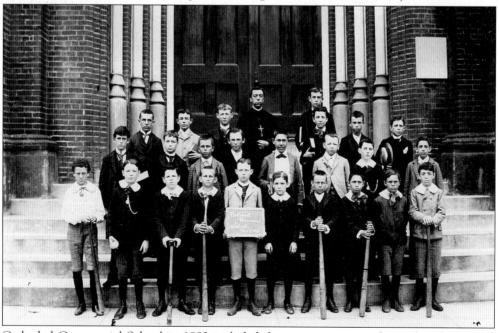

Cathedral Commercial School in 1892 included these young men in the student body. The significance of the baseball bats is a mystery, but baseball was perhaps the most popular sport among schoolboys then.

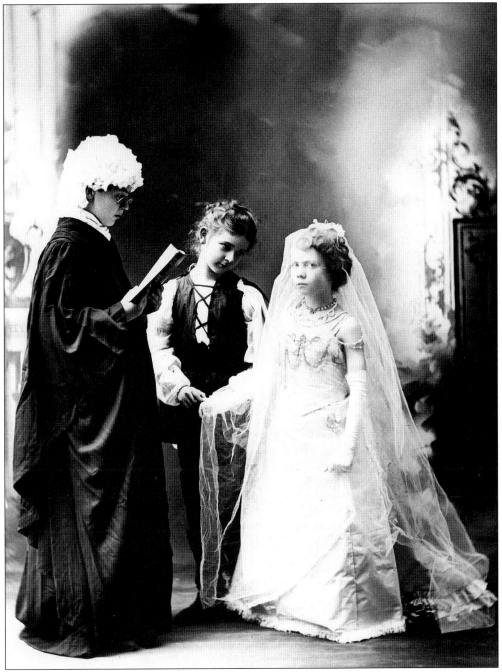

Consuela Bailey, the bride in this charming 1895 scene, pursued a career in the theater and became an actress of some note on Broadway.

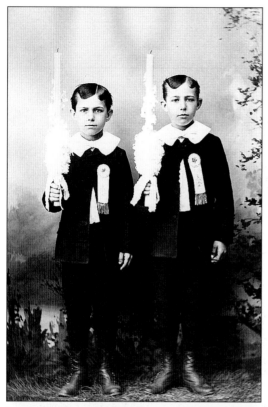

Photographs made by 19th-century Natchez photographers show religious events to be important in families' lives. Many children, attired appropriately for the occasion, went to the studio to have portraits made to commemorate the events. At left, Louis Andrew Kaiser and Paul Peter Kaiser pose in 1888. Their ribbons read, "Souvenirs of First Holy Communion." Below at left, the Martin babies, 1894, are double first cousins, Elsie, Margaret, and Hulda. When sisters Ethel, Juliet, and Bessie Rawle married, respectively, brothers Farrar, Lewis, and William Martin, little did they know that the three girls would come along so close together. The three babies were carried down the center aisle of Trinity Episcopal Church for the solemn occasion of their christening. The unidentified child below at right, about 1895, is enveloped by the typical enormous frothy frock known as a christening dress.

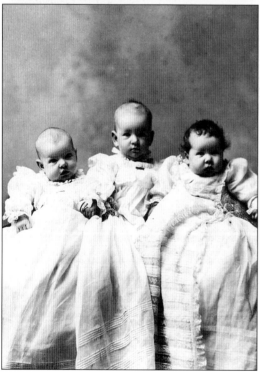

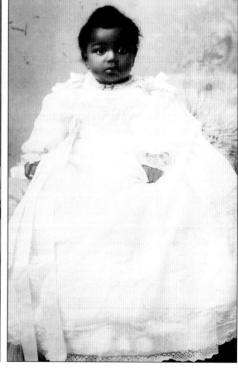

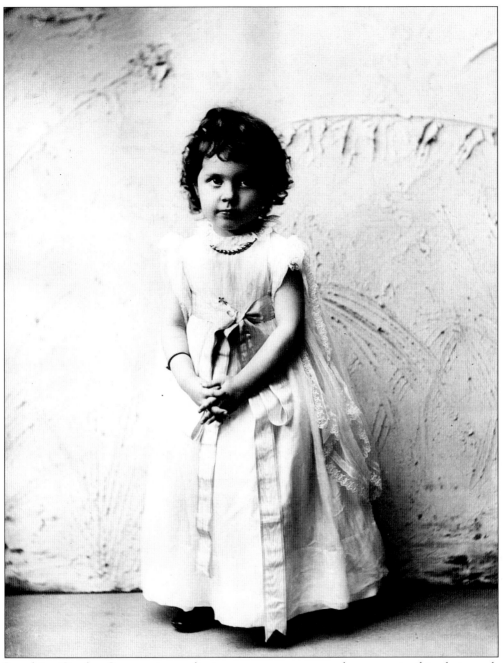

Josephine Carolyn Stratton is angelic in appearance, pose, and costume in this photograph made in about 1891. Carolyn grew up to marry Dunbar Merrill, pictured with his brother on p. 75. Her sister Lisa is shown on p. 34.

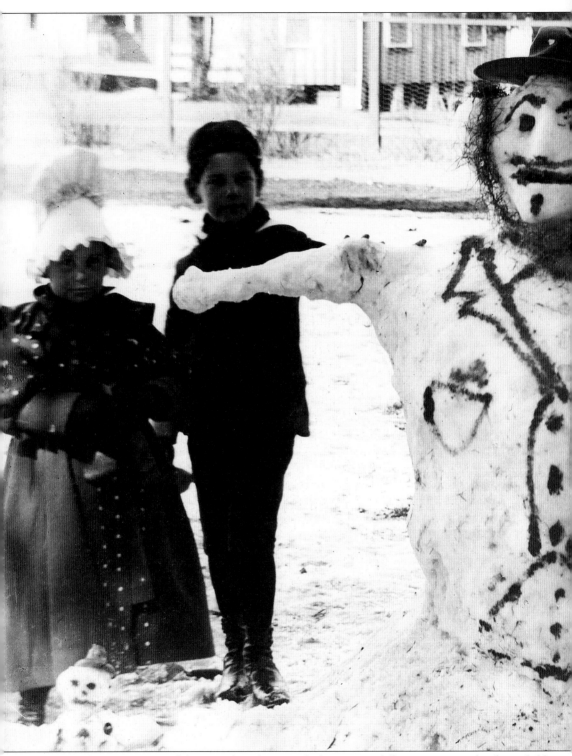

What better cause to celebrate with a photograph than a snowfall, a rare winter day for a child in Natchez. On such a day in about 1900, Lalie Lawrence, Lathrop Postlethwaite, Audley

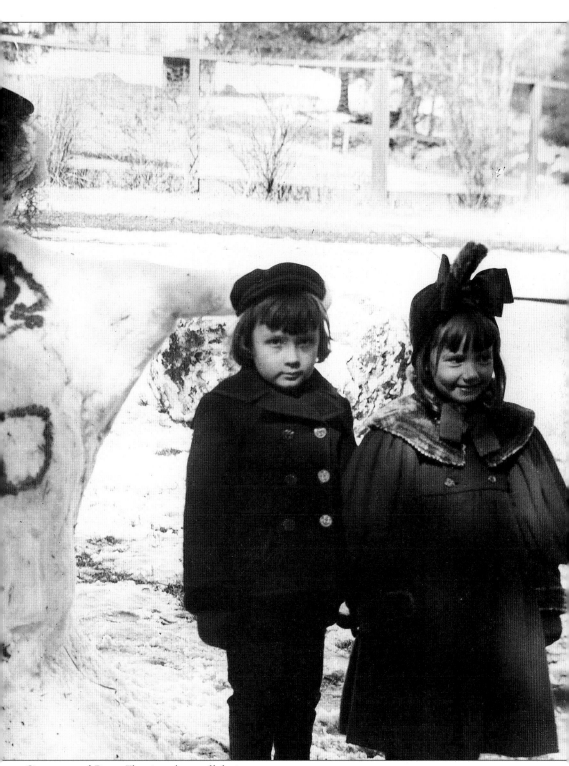

Conner, and Roan Fleming show off their snowman.

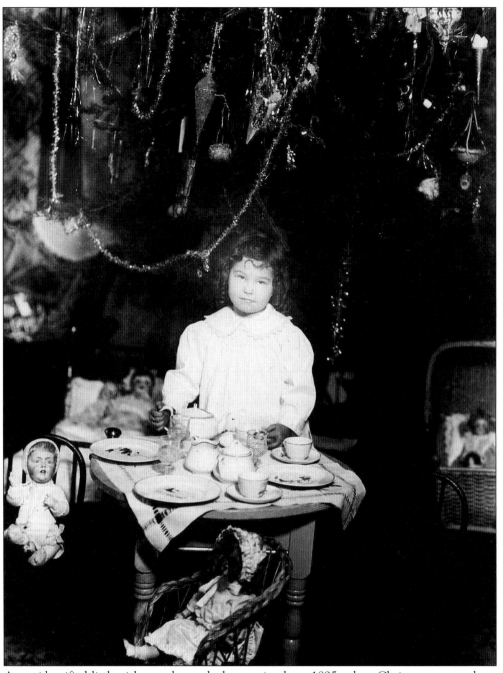

An unidentified little girl poses beneath the tree in about 1895, when Christmas was perhaps most splendid for fortunate children such as this one.

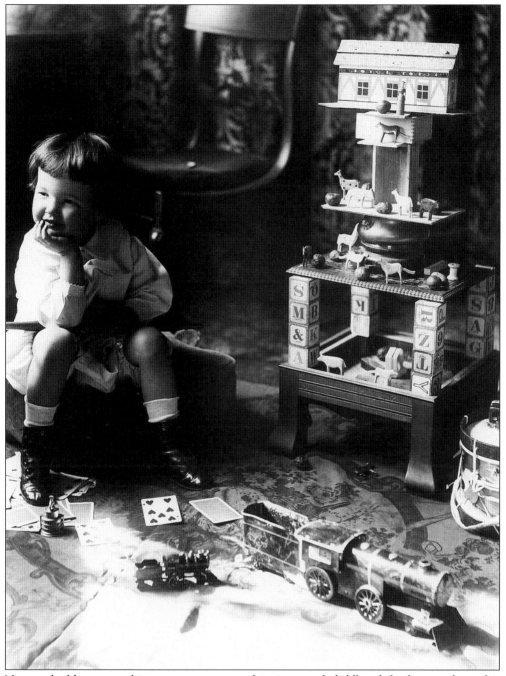

New and old toys combine to create a nostalgic image of childhood for boys such as this unidentified one, who smiles wistfully in about 1895.

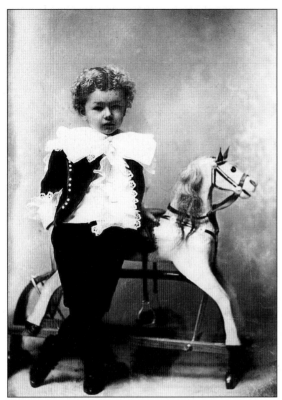

At left, three-year-old Joseph Carpenter stands with his fine toy horse in January 1897. Joseph lived with his family at the Natchez mansion Dunleith. Below at left, cousins Barnett Moses and Emma Moses wear their Mardi Gras finery. Both were grandchildren of David Moses, the merchant whose Cheap Cash Store on Silver Street at Natchez Under-the-Hill has been seen around the world in the 1990s as part of the front curtain of the revised stage show, *Show Boat*. Below at right, cousins Sam Geisenberger and Carlotta Geisenberger portray George and Martha Washington in 1899.

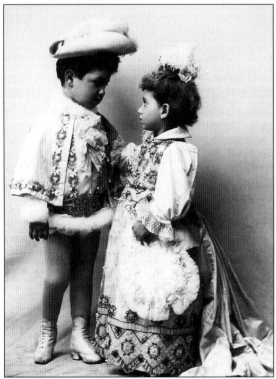

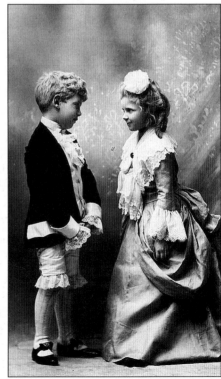

Anticipating the St. Louis World's Fair, which would open the next year upriver from Natchez, children participated in a pageant to generate excitement for the upcoming event. Any occasion—whether of local, national, or international significance—might inspire Natchez folks to have a pageant. Catherine Cameron Reed, below left, poses in 1905 in her Japanese costume as part of a celebration of the treaty between Japan and Russia signed that year. Below at right, Grace McKittrick is outfitted for a more traditional role, perhaps. In 1911, she was ring-bearer in the wedding of a family friend in New Orleans. A Natchez newspaper described her costume as "quantities of fluffy tulle." Grace grew up to become a prominent civic leader and philanthropist whose positions included that of president of Girl Scouts of America.

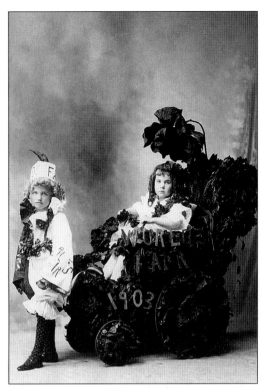

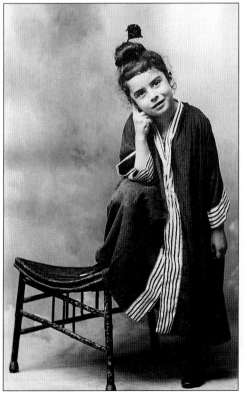

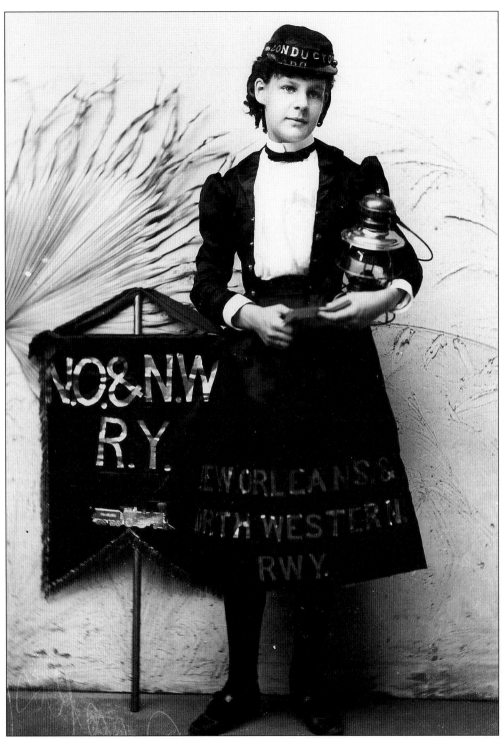

Miss Popkins was one of many young ladies who took part in a pageant to promote Natchez commerce and to raise funds for charity in 1891. Miss Popkins represented the New Orleans and Northwestern Railway.

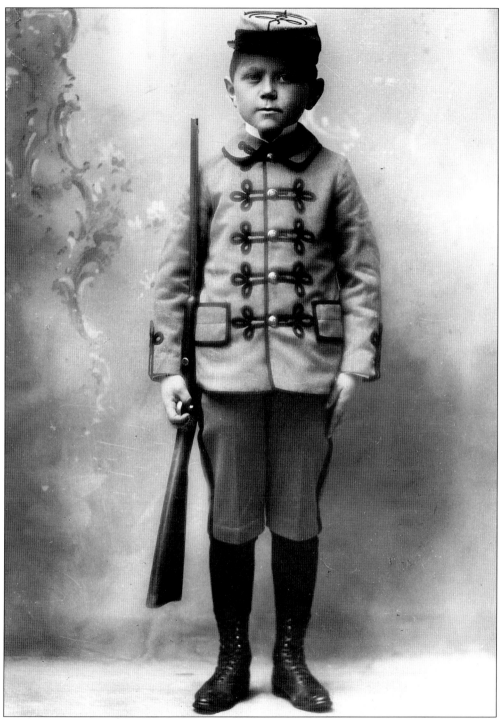

Jeff Tildsley presents his best military stance and expression as called for by his spiffy cadet uniform. In Natchez, the jaunty troops marching through town to the train station on their way to the Spanish-American War in 1898 were cheered on by children such as Jeff, who waved little American flags as brass bands played "There'll Be a Hot Time in the Old Town Tonight."

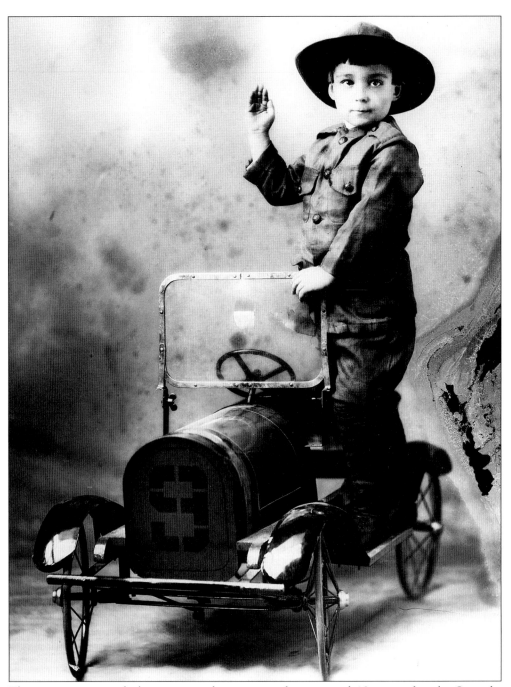

The same romantic idealism seen in the previous photo existed 18 years after the Spanish-American War, when some of the youngsters who had worn miniature uniforms of that era marched off to war as soldiers themselves, this time to the tunes of "Over There" and "You're a Grand Old Flag." World War I and the automobile, represented by a poignant image of a little Natchez boy, symbolize the end of an era for America, for the family, and, consequently, for children. America plunged into grim international politics; her people, off their porches and into the open road.

INDEX TO PHOTOGRAPHS